22 - VII - 1999

Mère Madeleine

Un souvenir de
l'Irlande pour votre jubilé

Merci infiniment
de votre gentilesse.

Seán Maher.

Valerie O'Sullivan

sacred moments

VERITAS

First published 1998 by
Veritas Publications
7-8 Lower Abbey Street
Dublin 1

Copyright © Valerie O'Sullivan 1998

ISBN 1 85390 339 6

Design: Bill Bolger
Printed in the Republic of Ireland by Betaprint Ltd, Dublin

contents

Dedicated to the memory of
Anne Fitzpatrick, Killarney
and her love for life.

FOREWORD

What a wonderful title for a book! As I journeyed through its pages I discovered how apt it was because a glow of warmth and joy flooded my being and the reading became for me a sacred moment. A realisation that all that is rich in Irish life is gathered here in a bouquet of ordinary and extraordinary living. This bouquet is interwoven with relevant quotes from the Psalms and our gifted poets. 'Though we live in a world that always seem about to give in, something that will not acknowledge conclusion insists that we forever begin...' Brendan Kennelly.

The joy of our singing and the glory of our Celtic creativity is here. Our ancient spiritual heritage is preserved by people of prayer and silence, people who connect our world to heaven through hours of meditation and creativity. Many of them are silent people who keep the world sane and oil the wheels of the mundane and make it beautiful. They are people who create the beauty in our churches and public places and raise our eyes to carry our minds on wings that break the barriers into the world of the wonderful. Then if, in later life, we have to look into dark pools, we may see reflected in their depths the starlight of that other world. There are times in life when we need to be carried by the genius of others in order to quarry our own crevices of genius.

As one who has done Lough Derg many times I found that the essence of the pilgrimage is captured within these pages. Should I return again I think that I would better understand the desire to return to that island of hardship.

Valerie O'Sullivan has walked amongst her own people with a discerning and true eye and what we have here is a picture of the spiritual underbelly of Ireland. We need to remember that it is there lest in forgetting we may lose our balance.

But while we have people who till the earth, challenge the seas and carve from stone, who sing with joy and seek peace in quiet places, they will preserve our spiritual roots. This book is an anthem to those people and an acknowledgement of all that is good in today's Ireland. Let us welcome it and be glad. It will sharpen our awareness of who we are and enrich our inner pool of spirituality.

Alice Taylor

Chapter One: **Vigils – The Nunnery**

St Mary's Abbey
Glencairn, County Waterford

on their way to lauds · good friday morning

Our life is one continual prayer; that is the aspect of the Church we represent.
 Sr Lily

> I have desired to go
> Where springs not fail
> To fields where flies no sharp and sided hail
> And a few lilies blow.
>
> And I have asked to be
> Where no storms come,
> Where the green swell is on the havens dumb,
> And out of the swing of the sea.

From *Heaven – Haven…a nun takes the veil*
by Gerard Manley Hopkins

The sisters at Glencairn begin their day at 4.00 a.m., and on Sundays and solemnities they rise at 3.40 a.m. The nuns pray seven times a day in accordance with the rule of St Benedict and the prayer times of the Apostles – just as Muslims are obliged to pray five times a day, so St Benedict: 'Seven times a day have I given praise to thee.' We shall observe this sacred number of seven if we fulfil the duties of our service in the hours of Vigils, Lauds, Terce, Sext, None, Vespers and Compline. The essence of the Benedictine Rule is 'Laborare est orare', and it is as simple as that – a life of work and prayer.

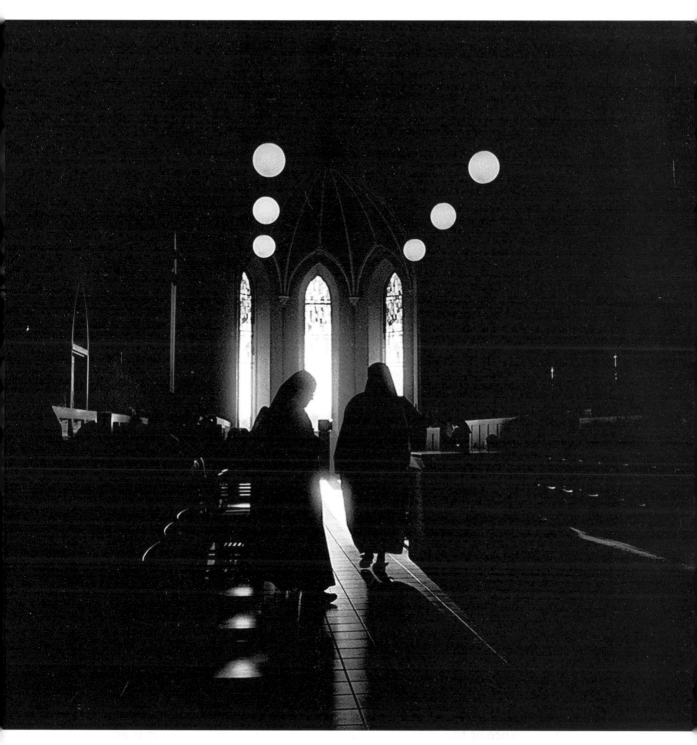

...and it was the sixth hour, and there was darkness over all the earth until the ninth hour.
And the sun was darkened and the veil of the temple was rent in the midst.
Luke 44:46

[3]

cistercian life is one of simplicity and what we eat reflects this.
Sr Lily

Working with silence they would eat.
2nd 3:12

Monastic food is both simple and frugal. The Rule of St Benedict requires 'a good pound weight of bread suffice for the day, whether there be one meal only, or both dinner and supper…whether it be at the sixth or the ninth hour, that every table should have two cooked dishes, on account of individual infirmities, so that he who perchance cannot eat of the one may take his meal of the other'.

In the absence of meat the daily repast at St Mary's Abbey consists of cereal, bread and coffee, for breakfast; a simple lunch at midday, usually potatoes and vegetables, followed by milk pudding; and bread and jam or scrambled egg at tea-time.

Meal-time is prayer-time. Prayer is resonated through scripture, psalms and religious writings. The sisters' prayer is in their silence, as the Rule asks them to love for silence.

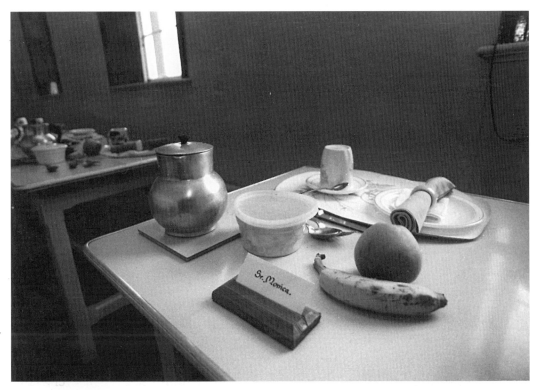

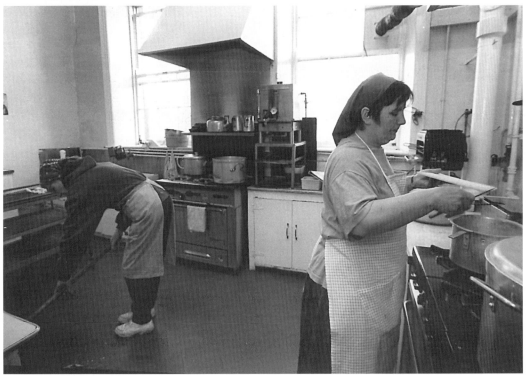

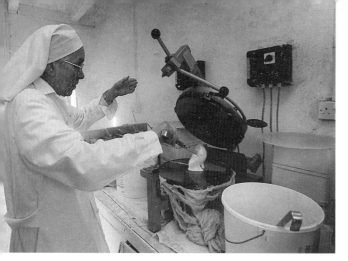

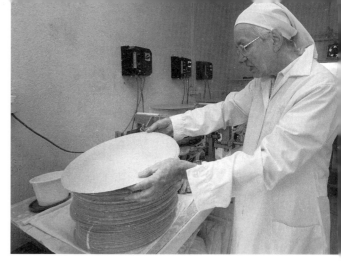

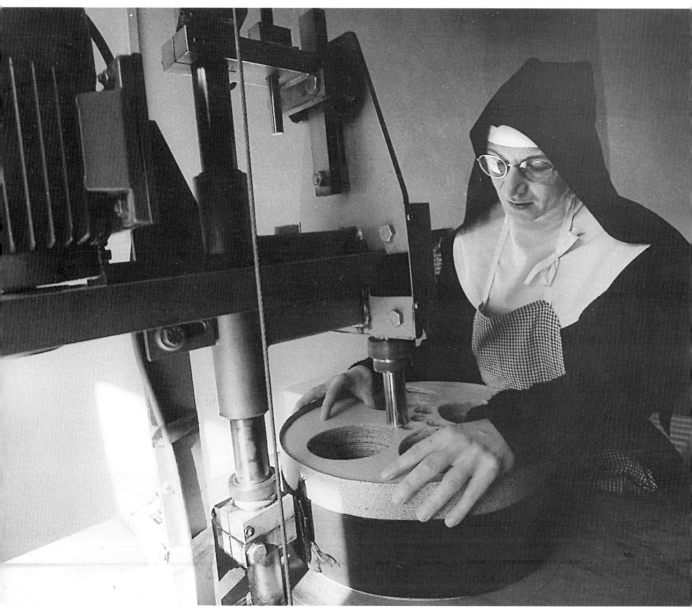

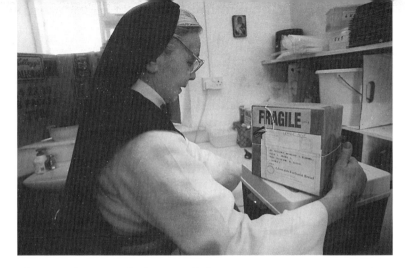

the making of the bread

Then he took some bread and when he had given thanks, broke it and gave it to them saying, 'This is my body which will be given for you; do this as a memorial of me...'
 Luke 22:20

As the Eucharist is the centre of the spiritual celebration of Christ, so too is the Eucharist at the centre of monastic working life.

The renowned eucharistic bread at Glencairn resembles everyday bread – 'the basics of life'. It is made according to the General Instruction of the Roman Missal which calls for a eucharistic bread 'which appears like actual food'. The hosts are large enough to be shared among the faithful. Sr Sarta bakes the bread until it is light brown in colour. It is cooked, humidified and dried twice a day. Sr Maria Christa cuts the thick bread into five different sizes, and it is then sent to the package room where Sr Clare prepares the boxes for the post. One package was bound for Italy, the other for Arbour Hill Prison in Dublin.

The administrators keep the orders rolling in: 'We've just broken the two million mark this year.'

If any brethren be at work at a great distance, so that they cannot get to the oratory at a proper time, let them perform the work of God in the place where they are working, bending their knees in reverence before God.
St Benedict, on working at a distance from the oratory

after terce...

I am the good shepherd: the good shepherd is one who lays down his life for his sheep.
 John 10:11

The Abbess at Glencairn Abbey is Sr Agnes O'Shea, originally from Callan, County Kilkenny. In accordance with the Rule of Saint Benedict she acts in the monastery as Christ's representative. 'I am elected by the sisters and my role is to teach, heal and guide the sisters with the gentleness and sensitivity of the good shepherd.' The administration of the monastery is also her responsibility, much of which she delegates to the sisters. By her prayer and example she creates an environment of warmth, acceptance and affirmation where the law of the Gospel is obeyed.

Sr Agnes is the silent leader of her community. She prays in the solitude and peace after Terce, the third hour, which commemorates the descent of the Spirit upon the Apostles and Mary at the mid-morning of Pentecost.

Its hymn evokes the spirit of God and its psalmody is entirely devoted to Psalm 118 – the Old Testament celebration of God's gift of the law to his people.

[8]

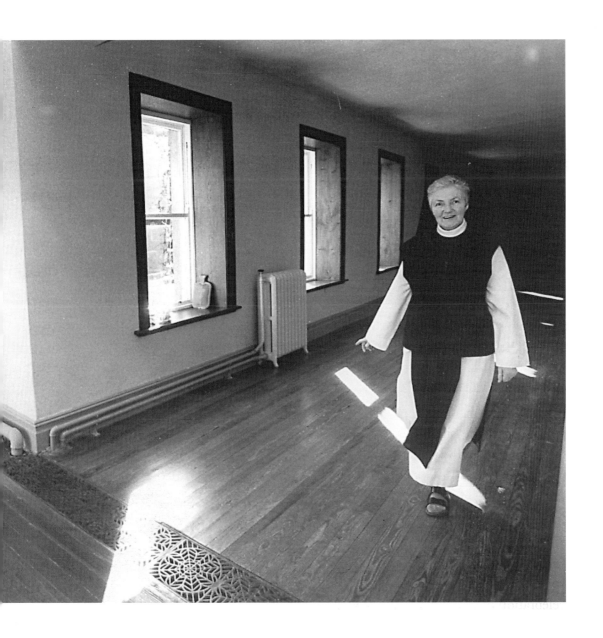

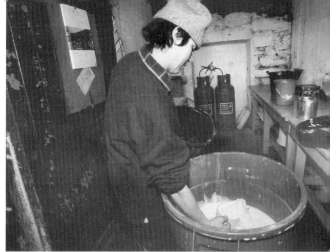

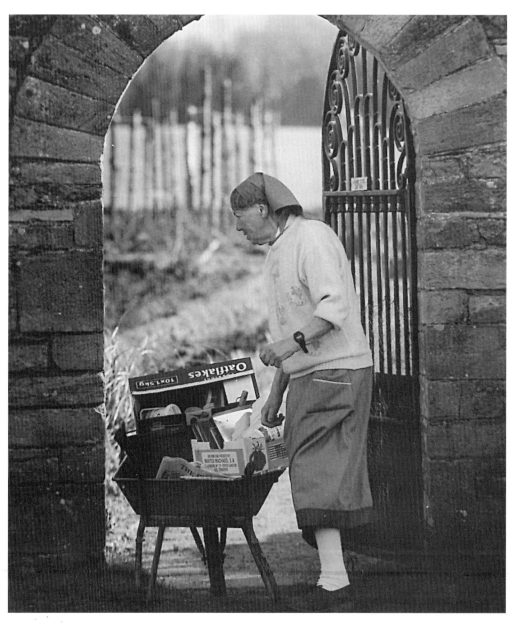

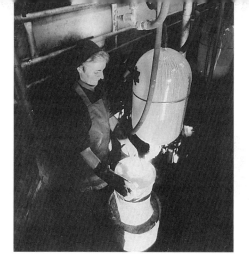

ᴅown on the farm

And she gave birth to a son, her firstborn. She wrapped him in swaddling clothes and laid him in a manger.
 Luke 1:7

Saint Benedict explicitly ruled out begging as a form of support for his monks. He wanted them to imitate the Apostles and the ancient fathers, who supported themselves with the work of their hands. His Rule says that his brethren should be occupied at stated hours in manual labour, and at other hours in sacred reading.

Glencairn nestles in the rich heartland of County Waterford. The main source of income is the dairy herd, with seventy cows on two hundred acres, and fifty acres of woodland. The sisters are involved in growing grass, making hay and silage, milking cows, once in the morning at 5.00, and again at 3.00 in the afternoon. They grow their own vegtables, and these too have order of place in the garden shed.

The milking is carried out by Sr Maria, who is also Novice Director at Glencairn. Her role is to accompany the newcomer through all the joys and trauma of her first years of life at the monastery. 'I introduce them to the observances and traditions of monastic life, helping each one to grow in Christ, and guide them through their vocational discernment.'

The newborn calves are tended to. The calves spend their first days in a shed appropriately named 'Nazareth'. After that they move on to another shed called 'Bethlehem'.

get thee to a nunnery...

Where two or three are gathered in my name, there I am in the midst of them.
 Matthew 18:20

The fourth prayer of the day, Sext, is at 12.40, when the sun is at its height. The sisters have accomplished half their day's work, and pause to enjoy the produce of their labours at the midday meal – itself a sacred symbol of the eucharistic union with Christ. It is a fitting time to celebrate the goodness and generosity of God to his created world.

As the bell rings out for prayer, the sisters arrive from all corners of the monastery. The morning's work is still on their hands, songs are sung, psalms are recited and, as in a ritual, they leave in single file and walk to the refectory in silence.

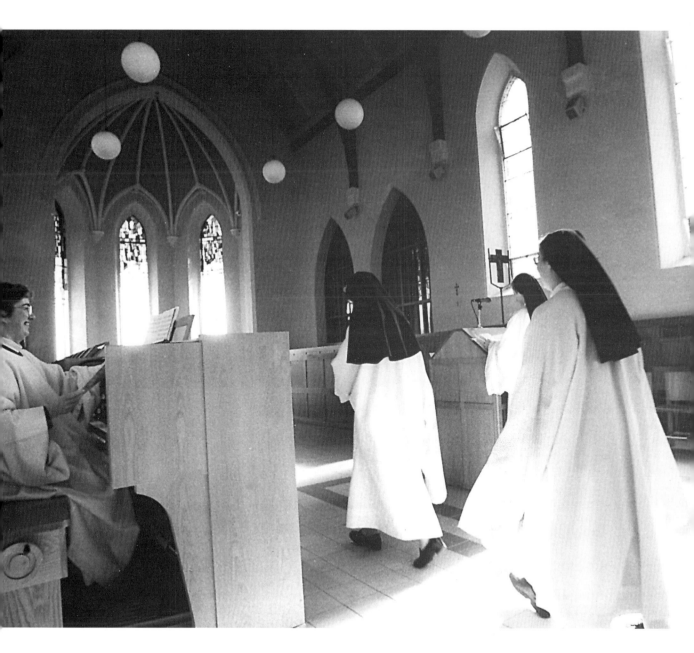

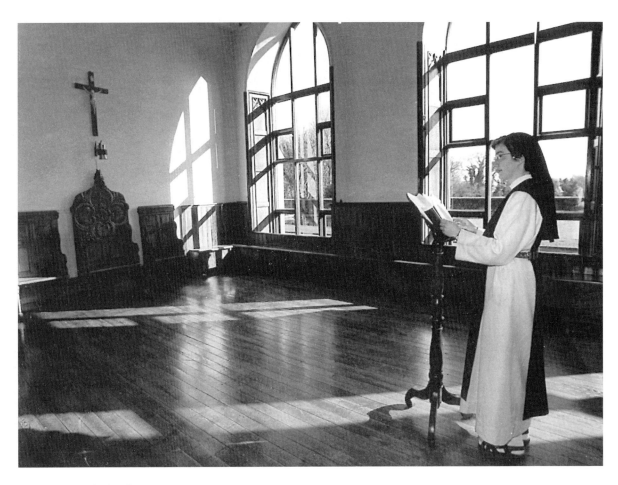

the chapter room

And when you speak you are praying not as the heathens for they think that in their speaking that they will be heard... thus therefore shall you pray: Our Father which art in Heaven.
 Matthew 7:9

All Benedictine monasteries have a chapter room – a meeting-room where the holy Rule is read and where the Abbess gives the talks and lectures. Choir and organ practice is also carried out here. The Rule of Benedict says: 'Our prayer ought to be short and pure in community. However, let prayer be very short, and when the superior has given the signal let us rise together.'
The chapter room is also where the community make decisions concerning the monastery and where the Abbess can consult the rest of the sisters about issues that may arise.

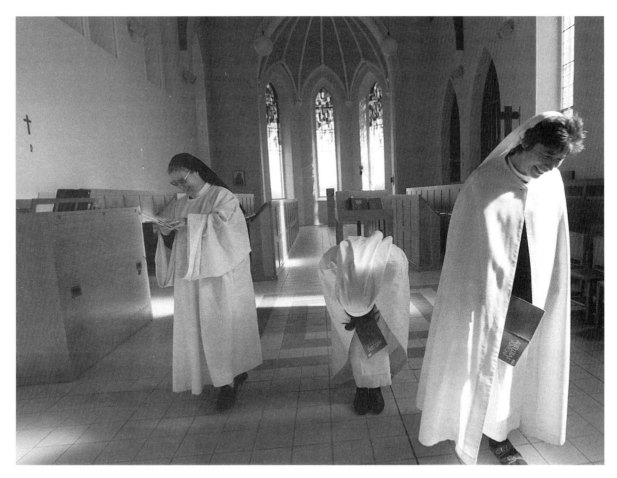

choir practice

Cry out with joy to the Lord all the earth, serve the Lord with gladness.
 Psalm 99

The Rule of St Benedict believes that God is present everywhere and the 'eyes of the Lord in every place behold the good and the evil', remembering the words of the prophet 'serve ye the Lord…sing ye wisely…in the sight of the angels will I sing to thee'. The Rule also instructs the monks to 'behave ourselves in the presence of God and his angels, and so sing the psalms that mind and voice be in harmony'.

The sisters practise the music liturgy of the Mass. Even though their performance is for God alone, they still feel a need as part of their reverence to God to make their song as perfect as their prayer to God is.

Psalm 22

The Lord is my shepherd, I shall not want.
He makes me lie down in green pastures;
he leads me beside still waters; he restores my soul.
He leads me in right paths for his name's sake.

Even though I walk through the darkest valley,
I fear no evil; for you are with me;
your rod and your staff – they comfort me.

You prepare a table before me in the presence of my enemies;
you anoint my head with oil; my cup overflows.
Surely goodness and mercy shall follow me all the days of my life,
and I shall dwell in the house of the Lord my whole life long.

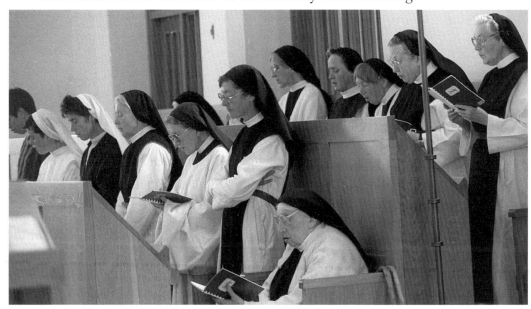

none...the ninth hour

It is you whom I invoke, O Lord. In the morning you hear me.
 Psalm 5:4

I will walk in the presence of the Lord in the land of the living. 'Glory be.'
 Psalm 114

 Doxology
Give praise to the Father almighty, to his son, Jesus Christ our Lord,
to the Spirit who dwells in our hearts now and forever. Amen.

None is the commemoration of the ninth hour when Christ gave his life to win us back to God and eternal joy. The life of the Cistercians is devoted to praying for the salvation of the world. Like disciples, they are carrying out God's work on earth.

Where other orders play a role in Christ's healing, teaching and pastoral work, the work of God at Glencairn is entirely prayer. The sisters' life and work move towards the Eucharist, the centre of the Church.

They wish for nothing other than to assist in the suffering that Christ endured while on earth. It is not surprising that Psalm 22 is sung at None.

The sisters believe they are not cut off from people, but carry them in their hearts and prayers. However, their lives are severed from materialism, greed, status and power as they try to live out the Gospel values; '...not an easy task'.

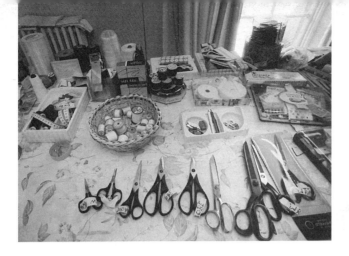

CRAftsmanship at Glencairn

a time to rend and a time to sew;
a time to keep silence and a time to speak.
 Ecclesiastes 3:7

St Benedict encouraged craftsmanship among his brethren, the Rule asking them to practise their craft with all humanity, provided the abbot gives permission. As regards the price: 'Let not the sin of avarice creep in; but let the goods always be sold a little cheaper than they are sold by people of the world, that in all things God may be glorified.'

The making of print cards and icons is an important source of income at Glencairn Abbey; the Christmas cards are sold worldwide. Although the sisters' job is tedious, time and prayer are on their side. The sewing-room is filled with orders – every item is numbered and labelled and every scissors has its place at the table. The sisters see craft work as a creative gift from God, and carry it out in acknowledgement of God's beauty and goodness on earth. It is also a form of therapy.

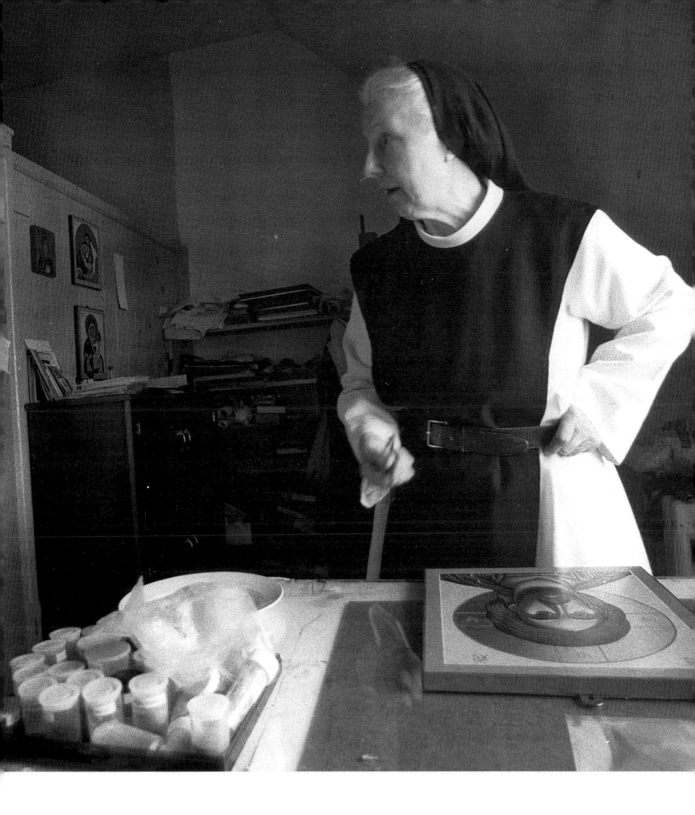

vespers...

For many are called, but few are chosen.
 Matthew 22:14

When I came to Glencairn that was it for me.
 Sr Philomena

As Lauds commemorates a beginning, the prayer of glory, Vespers, as the second great hour of the day, evokes a culmination, the gathering-in of the harvest, the triumph of the second coming, and the transformation of death into a passageway of light. Vespers proclaims the end. The pattern of Vespers matches that of Lauds, adding a canticle and substituting Mary's song for Zachary's.

Sr Philomena is the second novice at Glencairn Abbey. One of the youngest in the community, she entered the monastery over a year ago. A hairdresser by profession, she began to look for something deeper in her life. 'Although I was involved with social activities and loved being involved with the community, I needed a greater commitment in my life. When I came to Glencairn that was it for me.... As regards missing things, there are lots of things we take for granted; I was in business, I had my own car, my own money… all that has changed. I've made a different choice now. It's the life I want to live.'

after compline ...the silent hours...

And so I prayed... and the spirit of wisdom came to me.
 Wisdom 7:7

For historical reasons, Compline is an acquired hour. The second evening prayer, it is a quiet echo of Vespers on the shores of sleep, a final surrender to eternal life. Compline signifies the day's rest in the safe hands of Mary, ending with the liturgical prayer Salve Regina. The Rule of Benedict requires the monks to sleep in separate beds, 'ready for the rising at the signal, so that without any delay they may hasten to forestall one another to the work of God'.

The sisters retire at 8.15. St Benedict asked that no one speak after Compline: 'Monks should practise silence at all times, but especially at night....'

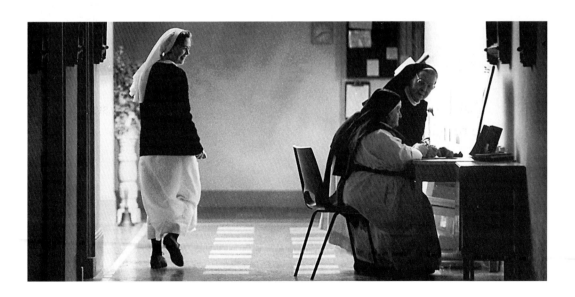

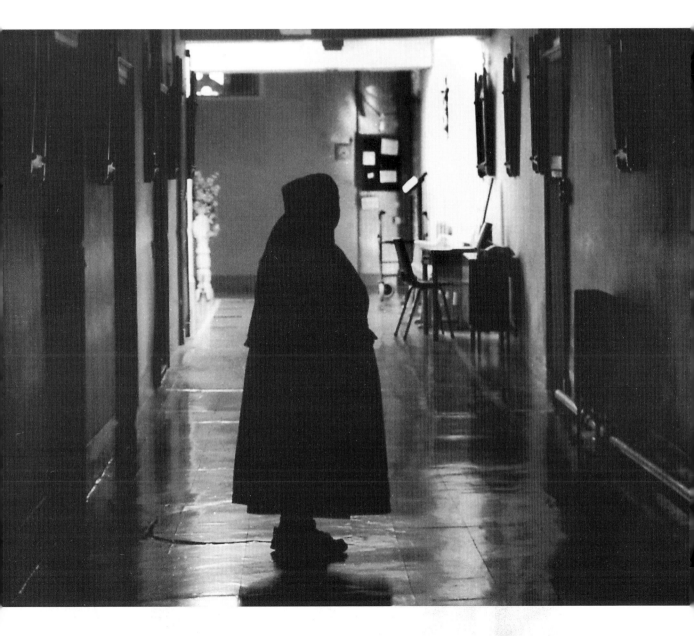

The final bell has tolled; the air is silent at St Mary's Abbey as the sisters render their day to the God of prayer and consolation and prepare for the next.

Chapter Two: **Lauds – Sacred Music**

Glenstal Abbey
Murroe, County Limerick

go into the sanctuary with praise!

Gregorian chant is an integral part of the Benedictine monastic experience.
 Brother Andrew Cyprian Love
 Organist at Glenstal Abbey

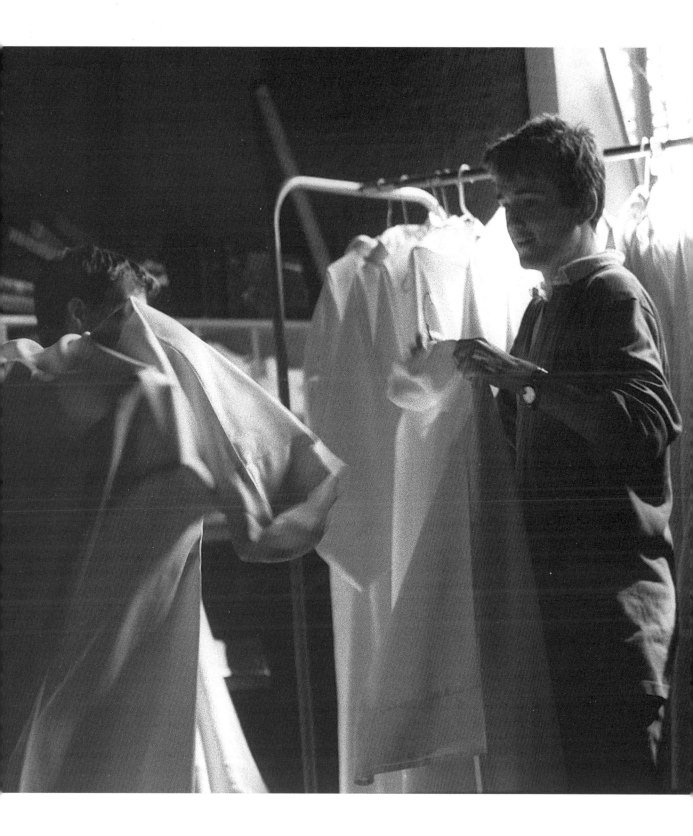

Cry out with joy to the Lord, all the earth.
Serve the Lord with gladness.
Come before him, singing for joy.
　　Psalm 99:1-2

Hymn on the morning of Christ's Nativity
　　By John Milton

Ring out ye Chrystall sphears
Once bless our human ears,
(if ye have power to touch our senses so)
　　and let your silver chime
　　Move in melodious time;
And let the base of Heav'ns deep organ blow
　　And with your ninefold harmony
make up full consort to th'Angelike symphony.
　　For if such holy song
　　Enwrap our fancy long,
Time will run back, and fetch the age of gold
　　And speckl'd vanity
　　Will sicken soon and die
And leprous sin will melt from earthly mould,
　　And hell itself will pass away,
And leave her dolorous mansions to the
　　　　peering day.

Gregorian chant is the integral and aesthetic dimension of the monastic adventure. It forms the core of the Church's daily offices as they are chanted from Vigils to evening Vespers. It charts the emotions at the different intervals of the Liturgy of the Mass with sombre responses, yet forceful acclamations. The sound is haunting and remains true to the Benedictine ethos and tradition. The monks at Glenstal Abbey, Co. Limerick, are Cistercians – Reformed Benedictines, they too live out the Rule of St Benedict, following the treasury of spirituality, harmony and wisdom. Fr Mark Tierney, historian and writer at Glenstal, remarks that 'there is a mystique about the Benedictine atmosphere as a world apart to serve God and provide a place where others can come and join. We don't come here to save our own souls.'

the choirmaster

I will sing to the Lord all my life, I will sing to my God while I live.
May my thoughts be pleasing to him. I will find my joy in the Lord.
　　　Psalm 103:33-34

Fr Paul Nash, from Bandon, Co. Cork, is choirmaster at Glenstal Abbey. He directs the singing for the Sunday liturgy and introduces the monks and school choir to new hymns and psalms. Under his direction the music is enchanting. The monks at Glenstal are enjoying the revival of interest in plain chant, and have produced authentic recordings from the Abbey, some of which include organ improvisations, and interpretations with singer Nóirín Ní Riain.

For hundreds of years the development of European music and culture was strongly influenced by the Christian Church. When the Roman Emperor Constantine was converted to Christianity in the fourth century he encouraged the spread of the faith within the Roman Empire. Missionaries like St Augustine were to carry this new religion to other parts of Europe. The principal music of the Church at the time was the chanting handed down from Judaism. It was St Ambrose, Bishop of Milan, who introduced a distintinctive form of chant throughout Christendom. This type of chant was based on the notes of four scales, which in turn were based on the structure of the old Greek modes. Two hundred years later Pope Gregory I approved the addition of four more scales or modes for use in musical acts of worship. The four original modes were known as authentic modes and the newer ones were called plagal modes. From this single pattern of plain chant music was taking on a whole new structure. Part singing called organism was introduced, followed by the addition of two lines of melody to be sung simultaneously. From this developed polyphony, which combined three lines of melody, the monk with the highest voice

The choirmaster

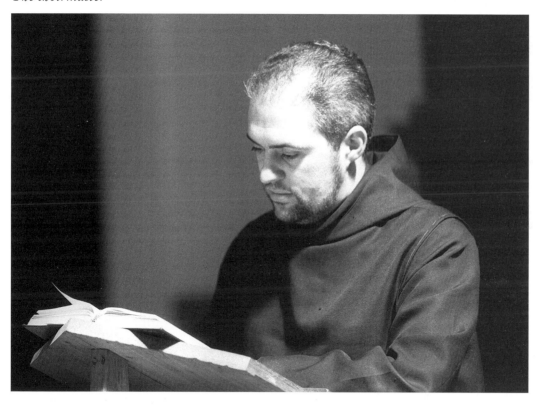

carrying the melody line. Beautiful harmonies and contrasting sounds gave style and colour tothe once unison verse. It was further enhanced by the eleventh-century monk Guido, who devised the idea of notation. The notes would now have a name as a reminder of a verse called the tonic solfa, which indicated the relationship between the notes in any scale and any piece of music using that scale.

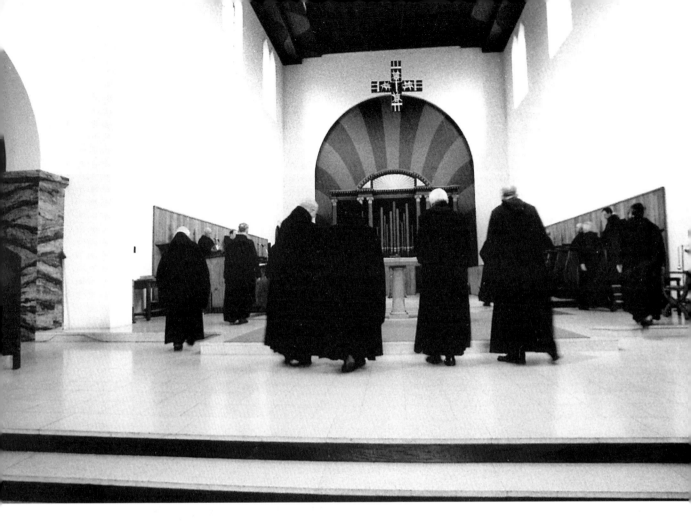

night prayer and evensong

From the rising of the sun to its setting praised be the name of the Lord!
 Psalm 112

Milton reminds us of the healing power that is in music. This brings us back to the old Orphic belief that when Orpheus played his lyre and sang, even the most savage animals would come out of the forest and lie peacefully at his feet. He could go down to the underworld and so charm the powers with his music that he was able to win release from the kingdom of death for his wife. What we are talking about is the healing power of music. When King Lear went mad on the heath the call was for music − the belief that the harmony in the music would restore his harmony. The old belief that like creates like.

 John Moriarty

the light of christ...

As the flame is the figure of the soul, and the figure of the living God, the candle is the physical element that radiates the heat and warmth of God's presence. They both possess a spiritual symbiosis and, as night approaches, the flame radiates light. 'God is light, in him there is no darkness', and the candle an eternal, a trusting warmth. This is vividly symbolised on Easter Saturday night, when the Paschal Candle representing Christ is lit. The deacon chants Lumen Christi three times, each time in a higher tone. Every candle in the Church is lit from the Paschal Candle. There is no need to be afraid. Christ is alive in us – 'the light of Christ has come into the world'.

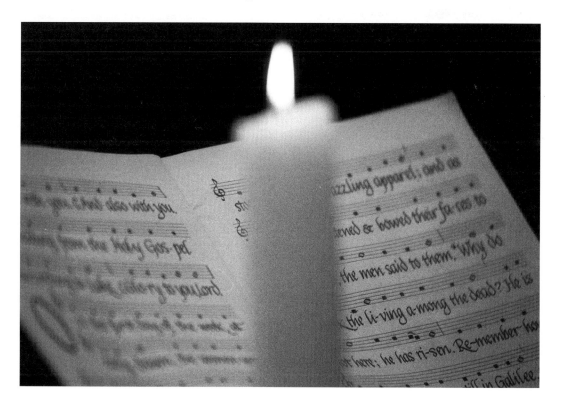

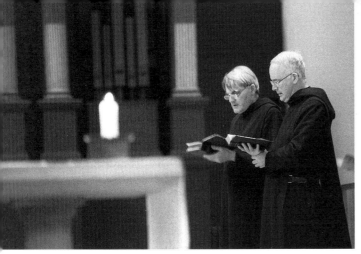

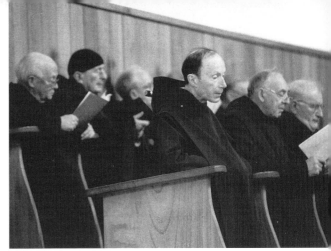

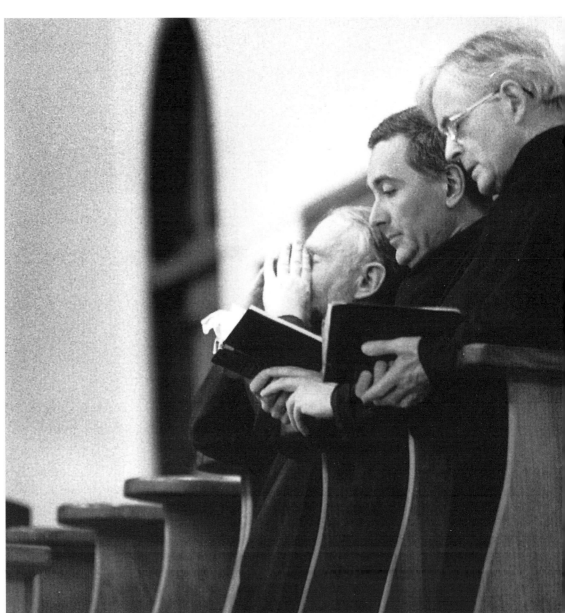

awake from your slumber… arise from your sleep

There is one thing I ask of the Lord, for this I long, to live in the house of the Lord all the days of my life…

 Psalm 26

At Glenstal Abbey, morning prayer, Vigils, at 6.30 , follows the Benedictine pattern. The monks arrive in single file and in silence. The sound of their psalms from the Canticles of David echoes gently through the church, as they sing in praise of another day with God in the house of the Lord.

From the feast of Easter until Pentecost let Alleluia be said always both with the psalms and with the responses. On every Sunday out of Lent, let Alleluia be said with the canticles of Matins…

The plain chant which had been in use in Jewish synagogues had flourished in worship from the infancy of Christianity. Pope St Gregory was the earliest champion of plain chant in the Catholic Church – hence the term 'Gregorian Chant'. However, the contribution of the Benedictine monks of Solesmes in France is immeasurable. They worked relentlessly to preserve the corpus of Church music, collecting and copying manuscripts from libraries all over Europe. In 1881-83 they produced two very important volumes for which they were to win papal privileges. This music formed an integral part of the spiritual life of the monks whose hours were marked by the singing of the sacred office every day.

There was also a change in the actual style of performance – it now had greater rhythmic impetus and a lighter delivery. Monks would sit at each side of the chapel and alternate the psalm verses. Poetry and verse were added to the prayer times.

Selected hymns were introduced, most notably those of St Ambrose who wrote wonderful hymns of praise to God, including The Trinity and Te Deum.

The anonymous hymn Veni Creator, Come Holy Spirit, would be sung at the ordination of a priest or a monk. In a peculiar way these hymns still provide the same inspiration and momentum as they did in the Middle Ages in the Church generally and in the monasteries of Europe.

shout to god with songs of gladness!

O sing him a song that is new, play loudly, with all your skill.
Psalm 32:3

At Terce, Sext and None, let the remaining nine sections of the hundred and eighteenth psalm be said. Three at each of these hours...
St Benedict on the order of Psalms to be said

Gregorian chant differs greatly from harmonic music, structurally and otherwise. It is a single vocal melody which does not follow a rigid rhythmic pattern, but rather follows a free natural speech-like rhythm which is dictated by the accentuation of the Latin language which the music serves. Texts are drawn from the Psalms of King David and the prayers of the Mass. The melodies of the sacred office are based on a very ancient modal system which also includes Irish sean-nós music and songs. There is a direct line of development to the later more sophisticated and complex structures of the renaissance and baroque motets. Palestrina and Victoria freely incorporated and quoted directly from the works of their predecessors, the Benedictine monks who had for so long remained anonymous. Plain chant has been the most powerful musical medium of the expression of the sentiments of Church music since the dawn of Christianity. It is alive and flourishing today, some fifteen hundred years later, in Benedictine monasteries and abbeys all over the world.

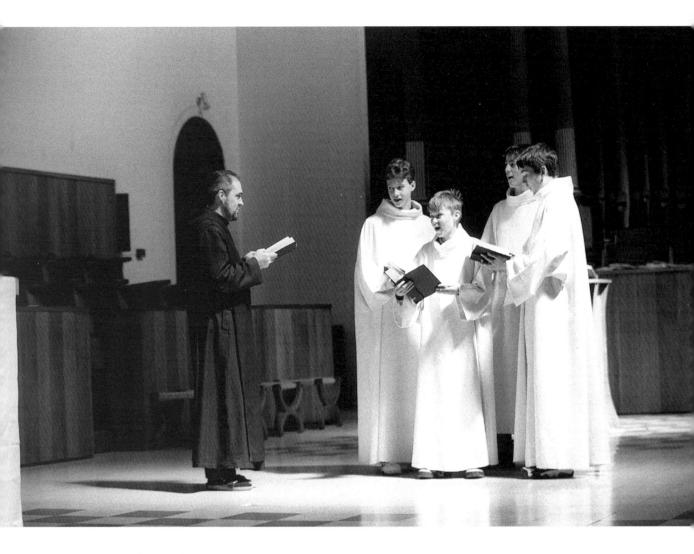

the schola

The students from the boarding school at Glenstal Abbey greatly enhance the choir singing at the Abbey. They practise here in preparation for the Sunday liturgy with Choir Director Fr Paul Nash. The students include Tim Reilly, Clonmel, William Hopper, Wexford, Darragh Brogan, Ballyhaunis, and Michael Fitzgibbon, Tralee.

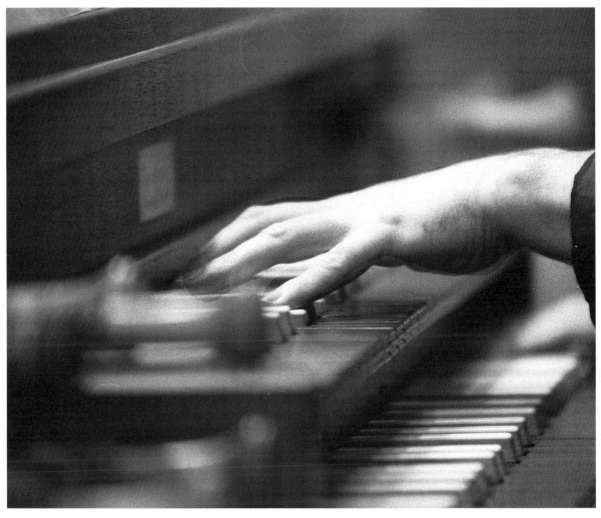

ᴀɴᴅ ʟᴇᴛ ᴛʜᴇ ʙᴀsᴇ ᴏꜰ ʜᴇᴀᴠ'ɴs ᴅᴇᴇᴘ ᴏʀɢᴀɴ ʙʟᴏᴡ...

With trumpets and the sound of the horn acclaim the King, the Lord.
 Psalm 97:6

For an organist Bach is like a living structure of the air you breathe.
 Brother Cyprian Love

St Cecilia, the patron saint of music, is associated with the organ. 'Bright Cecilia raised the wonder higher: when to her organ vocal breath was given' (Dryden). St Cecilia had in earlier times despised the organ and was said to have closed her ears when she heard it being played, but by the time of the Renaissance she was to inspire poets and painters alike.

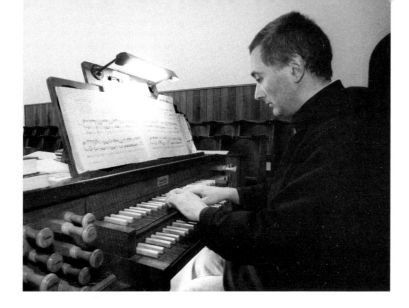

The organ was a major embellishment of Church music. Its powerful structure and ornate sound influenced composers like Bach, whose strong Lutheran tradition is emphasised in his masterful choral preludes, fugues and toccatas. Bach's passion for organ and Church music is preserved in his most famous works: the *B Minor Mass*, the *Matthew Passion* and the *St John Passion*, his *Christmas Oratorio* and hundreds of cantatas.

Handel devoted his attention to oratorio, and his *Messiah*, first performed in Dublin in 1742, includes the famous Hallelujah Chorus.

Brother Andrew Cyprian Love is organist at Glenstal Abbey. He studied at the Royal College of Music in London and taught English at Glenstal before entering as a monk five years ago. He speaks passionately about the organ which was built by Kenneth Jones in 1981, using some of the original pipe work. 'Because of the organ's natural complexity it is gently tuned every three months'. Gregorian chant allows for improvisation, so that the mastery of the piece is unconditional and is always enriched by the sound of the choir. Brother Cyprian is a great lover of the music of Bach, and he also enjoys playing some of Widor's toccatas and pieces from early French repertoire, including Couperin, as well as Dupré and Messiaen.

Chapter Three: **Terce – Pilgrimage**

Lough Derg, Centre of Celtic Spirituality
Saint Patrick's Purgatory
Pettigo, Co. Donegal

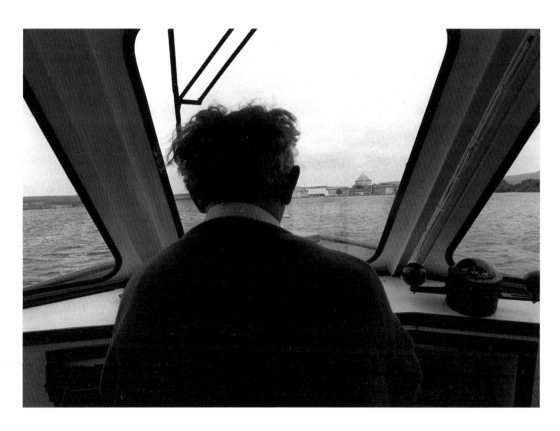

My feet were so cold, the warmest place to put them was in the water.
 Pilgrim

Pilgrims are strongly recommended to bring warm and waterproof clothing; the rest of the work relies on the strength of your soul.

Jamesie Monaghan, from Pettigo, has rowed and steered pilgrims to Lough Derg 'for years and years'.

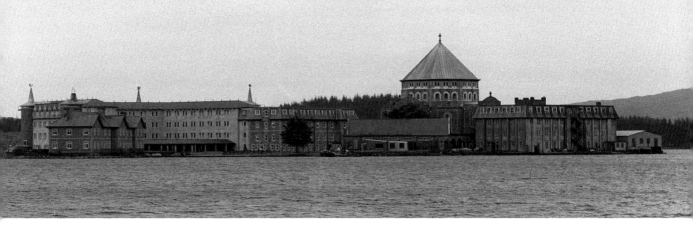

making the pilgrimage to lough derg

If there is any of you who needs wisdom he must ask God, who gives to all freely and ungrudgingly; it shall be given to him. But he must ask with faith, and no trace of doubt, because a person who has doubts is like the waves thrown up by the sea when the wind drives.
 James 1:5-6

In ancient times pilgrims journeyed from St Patrick's Purgatory, Lough Derg, to sunny Tuscany in Italy to cleanse the eternal soul. For those who doubt its purpose, the value of pilgrimage is expressed clearly in this old Irish poem:

 To go to Rome
 Is little profit, endless pain,
 The Master that you seek in Rome
 You find at home or seek in vain.

 Techt do Róim,
 Mor saitho, becc torbai,
 In Ri con-daigi i foss,
 Manim bera latt ni fhogbai.

St Patrick's Purgatory, Lough Derg, Co. Donegal, is the historic centre of Celtic spirituality in Ireland. This ancient island sanctuary has been a retreat for prayer and penance for nearly one thousand years, challenging human frailty and exposing the human soul. The pilgrimage is physically demanding and involves deprivation of sleep and food, and a commitment to walking barefoot while on the island. The idea of sacrifice has always been an important religious experience, providing a stepping-

stone beyond the physical and mortal being and reaching the depths of the soul. It cleanses the mind and provides inner peace and reconciliation, and rewards the pilgrim with a new strength for life's journey. Pilgrims come to Lough Derg because of the intensity of this experience as a total requited love of God; genuine pilgrims leave the island with a tremendous feeling of satisfaction, having dealt with their need, and having achieved what they set out to do. The pain of fasting and the lack of sleep are no longer at issue – they have surpassed all that, and have vouched, with the thousands of other pilgrims, that they'll return to Lough Derg the following year.

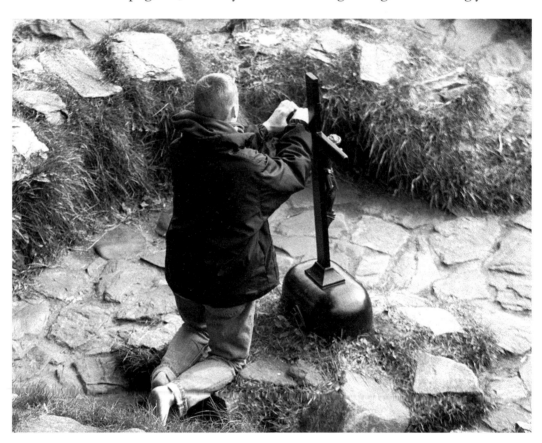

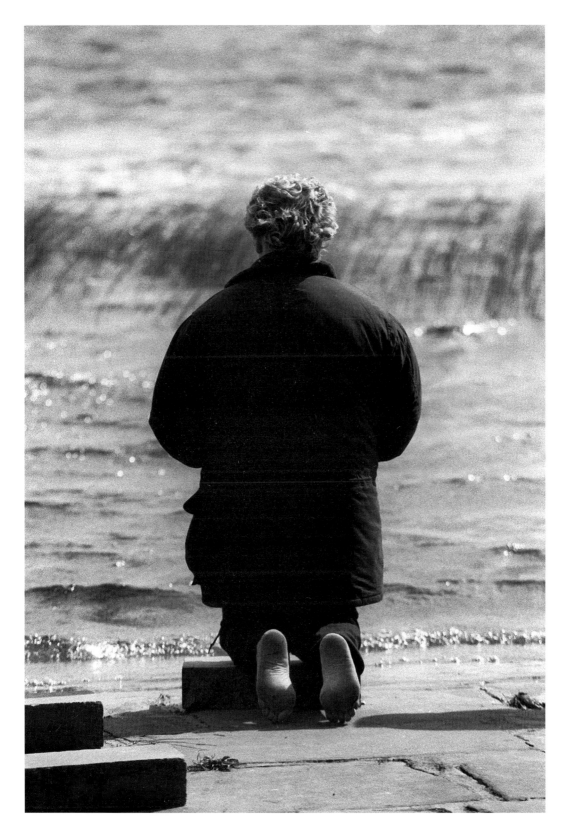

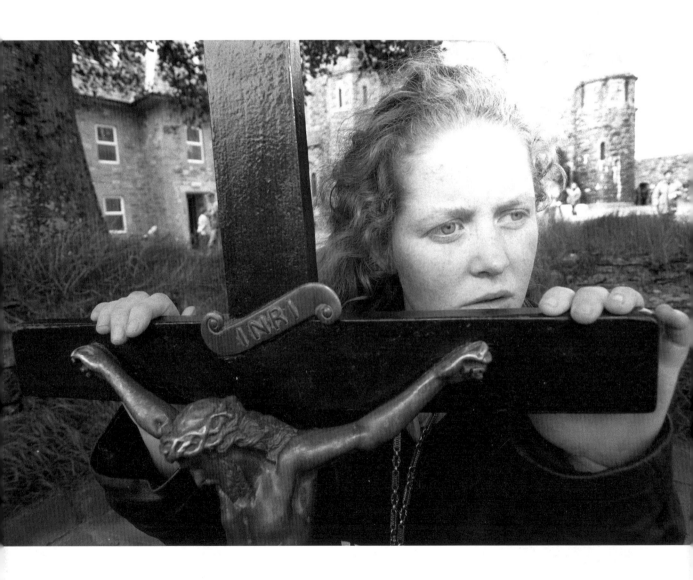

Elizabeth Connors from Enniscorthy making her first pilgrimage to Lough Derg

REMEMBER WHAT PEACE THERE MAY BE IN SILENCE

O God, you are my God, for you I long: for you my soul is thirsting. My body pines for you.
 Psalm 62:2

Journeys by pilgrims to holy places in order to obtain God's help or as acts of penance and thanksgiving are part of an ancient and common tradition. Just as Hindus and Muslims have their Benares and Mecca, Christians feel a natural desire, deep-rooted in tradition, to journey to places particularly touched by God or blessed by our holy saints. This mysterious presence is a natural progression in Christianity from its central belief in the Incarnation. By the eighth century the devotion and veneration of the saints and images at the sites of these pilgrim places opened up sanctuaries like Santiago de Compostela, Jerusalem and Bethlehem. The ideal of sacrifice and pilgrimage holds true in almost every faith and belief since the beginning of time.

unless you repent you will perish

Have mercy on me, God, in your kindness. In your compassion blot out my offence. O wash me more and more from my guilt and cleanse me from my sin.

Psalm 50

Saint Patrick's Purgatory was where St Patrick was vouchsafed a vision of Purgatory in the island's cave – an entrance into the underworld, a temporary existence where the soul was purified and cleansed after death, a transient state where sinners would endure the most horrific acts of penance in order to free their soul from sin. This belief in Patrick's vision and entrance into the underworld spread rapidly. The island cave would soon be established as the chief pilgrimage in Ireland. Such was the reputation of this purgatory as a daunting pilgrimage that only men would dare to endure the savage nights. At one point there were visions of heavenly angels, soon suppressed by visits from evil spirits, torrents of fire and water, and severe pain and suffering. The body was wracked with pain by morning, but the soul was deemed to be cleansed through these acts of penance. The appeal of St Patrick's Purgatory was paramount. It survived the Dark Ages and only after the age of superstition subsided was the cave demolished. The site of the purgatory and pilgrimage was established on a smaller island – Lough Derg. Once you leave the mainland and travel across to Lough Derg, the physical stepping-stone is made. Then begins the three-day spiritual and physical exercise of prayer, penance, self-denial and vigil, when the pilgrims are together in body but alone in spirit.

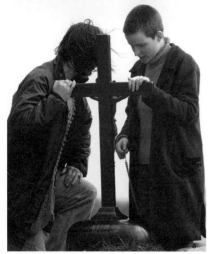

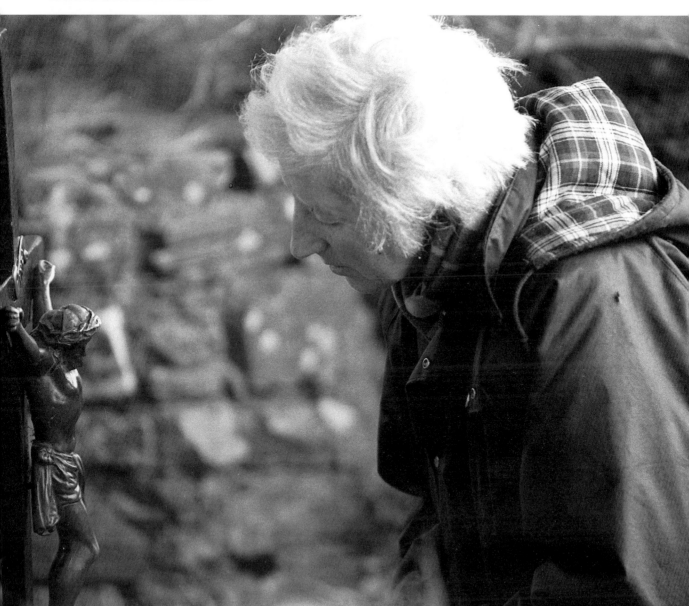

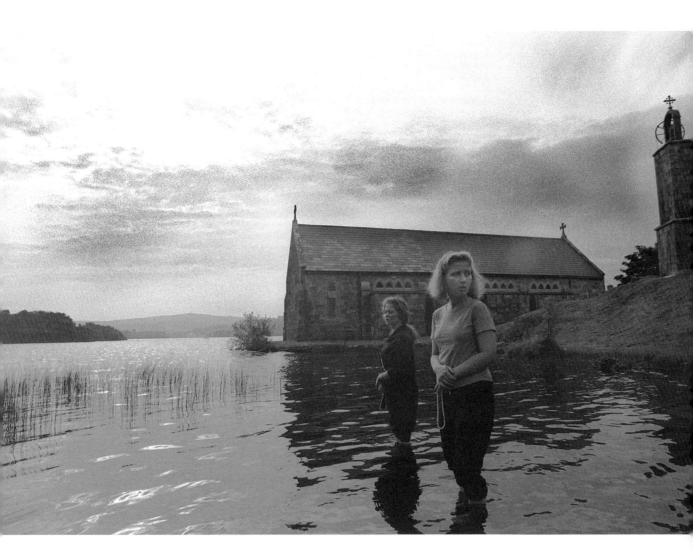

the pilgrimage exercise

(approved by the Bishop of Clogher)

Cleanse me of sin with hyssop, that I may be purified; wash me, and I shall be whiter than snow. Let me hear the sounds of joy and gladness; the bones you have crushed shall rejoice. Turn away your face from my sins, and blot out my guilt.

A pure heart create for me, O God,
put a steadfast spirit within me.

Excerpts from Psalm 50
The Miserere: Prayer of Repentance

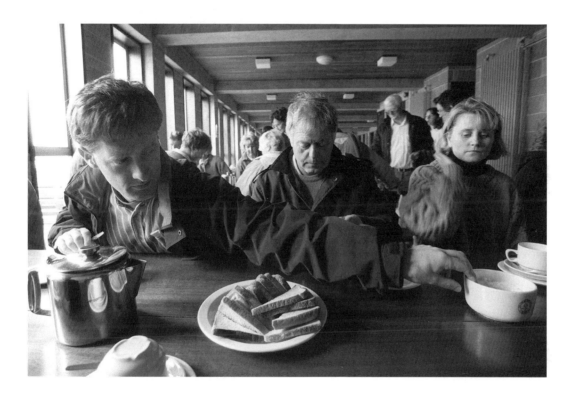

the fast

From midnight prior to arriving on Lough Derg the pilgrim observes a complete fast from all food and drink, plain water and prescribed medication excepted. The fast continues for three full days, during which one Lough Derg meal a day is allowed. The first meal may be taken when the pilgrim has completed at least one station, the second at any time in the afternoon of the second day, and the third at any time on the third day after leaving Lough Derg. The meal on the third day should be similar to those taken on the island. On this day pilgrims may also drink mineral water as often as they wish after departure. The fast ends at midnight on the third day.

the vigil

The Vigil is the chief penitential exercise of the pilgrimage and involves complete and continuous sleep deprivation for twenty-four hours. It begins at 10.00 on the first evening and ends after Benediction on the second day, when the pilgrims retire to bed.

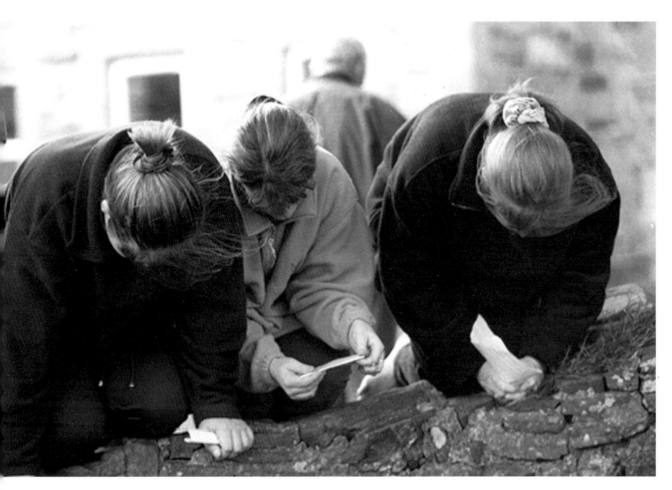

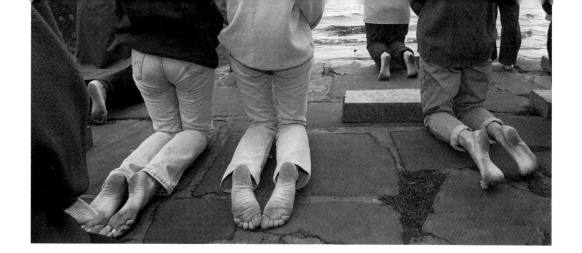

the stations

Having arrived on the island the pilgrim goes to the hostel, removes all footwear and begins the first Station. Three Stations are completed before 9.20 p.m. All the prayers at these stations are said silently. The prayers at the remaining four Stations are said aloud in unison in the Basilica during the night of the Vigil. Between these stations pilgrims may leave the Basilica, use the night shelter and walk around the immediate vicinity of the Basilica only, taking care to keep their voices down. A further Station is made outside in the morning, after the Sacrament of Reconciliation, and a final one on the third day after Mass.

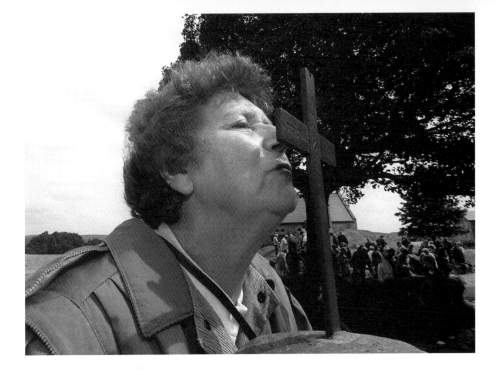

begin the station with a visit to the blessed sacrament in st patrick's basilica

Then go to St Patick's cross near the Basilica; kneel and say one Our Father, one Hail Mary and one Creed. Kiss the cross.

Since you, O God, are my stronghold, why have you rejected me?
Why do I go mourning oppressed by the foe?

O send forth your light and your truth; let these be my guide.
Let them bring me to your holy mountain, to the place where you dwell.
 Psalm 42:2-3

Pilgrims arrive on the island between 11.00 a.m. and 3.00 p.m. on their first day, having fasted from the previous midnight. The central prayer of the pilgrimage is called a 'Station' and is made barefoot. As in the Celtic forms of prayer, a Station is a series of movements accompanied by a mantra-type prayer. Three such Stations are made in the open air on the penitential beds, which are remnants of the beehive cells of the ancient monks. The prayers of four more Stations are said in unison in the basilica during the night of the vigil and one is made outside on each of the second and third days. Mass is celebrated in the basilica on each morning and evening of the pilgrimage. Pilgrims have one simple meal of dry toast with black tea or coffee on each day.

GO TO SAINT BRIGID'S CROSS

Have mercy on me, God, in your kindness.
In your compassion blot out my offence.
O wash me more and more from my guilt
and cleanse me from my sin.
My offences truly I know them;
my sin is always before me.
Against you, you alone, have I sinned;
what is evil in your sight I have done.
That you may be justified when you give sentence
and be without reproach when you judge,
O see, in guilt I was born,
a sinner was I conceived.
Indeed you love truth in the heart;
then in the secret of my heart teach me wisdom.
Psalm 50:1-8, a Psalm of David when Nathan the prophet came to him after his
sin with Bathsheba

The hunger hits you the first day, then the sleep gets
to you the second day. It's hard work trying to pray.
 Pilgrim

It must be the battle with sleep… but there is nothing to compare with putting
on your socks and shoes the following morning.
 Pilgrim

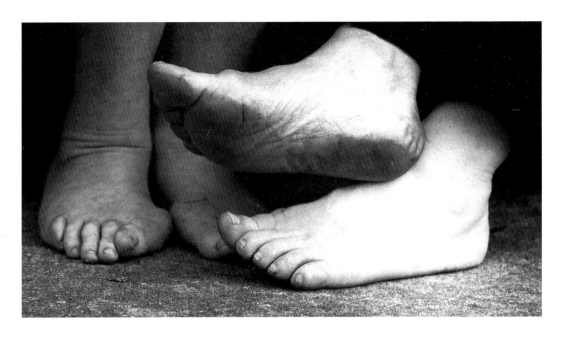

walk slowly by your right hand

This is what Yahweh asks of you: only this, to act justly, to love tenderly and to walk humbly with your God.
 Micah 6:8B

To walk barefoot together has the effect of bonding people; it intensifies the experience of fellowship and community which is the very essence of pilgrimage. It is also an act of humility – just as Christ washed the feet of his disciples before the Last Supper, they too may share with others his example of service to the meek and lowly. Feet washing also marks the beginning of the Easter Triduum on Holy Thursday, in the build-up to the most important celebration in the Church's Calendar – Easter Sunday – when Christ humbled himself to die on the cross and rose again to save our mortal souls.

The pilgrimage never gets easier, even after fifteen years. It must be the sheer sense of achievement, maybe.
 Pilgrim

Walk slowly by your right hand four times around the Basilica while praying silently seven decades of the Rosary and one Creed at the end. Go up to the edge of the lake to the penitential cell or bed called 'St Brigid's Bed'.

[54]

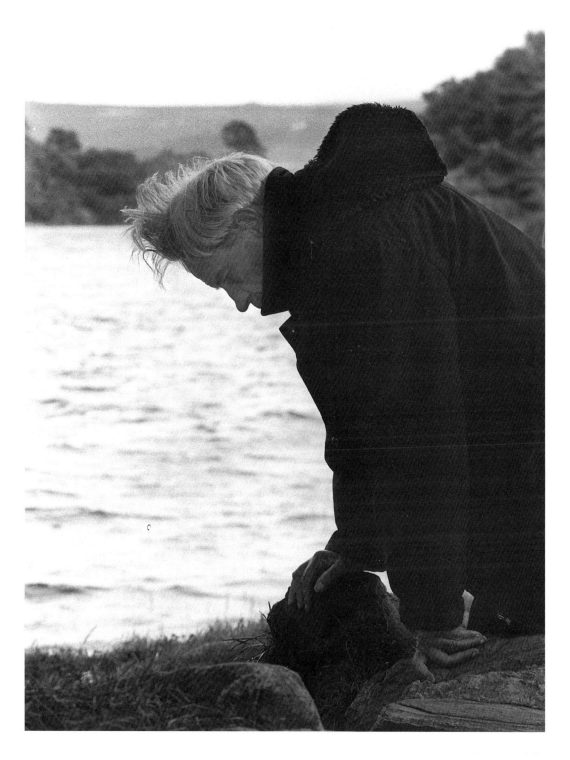

An tAthair Pádraig Ó Saoraí, Dublin, who has made the pilgrimage since 1953

Eileen Ginty and Helen Butler from Killnacross, County Leitrim

at the bed

Walk three times around the outside, by your right hand, while saying three Our Fathers, three Hail Marys and one Creed. Kneel at the entrance to the bed and repeat these prayers; walk three times around the inside and say these prayers again. Kneel at the cross in the centre and say these prayers for the fourth time. Repeat these exercises at St Brendan's Bed, St Catherine's Bed, St Columba's Bed.

in the noisy confusion of life keep peace with your soul

I cry aloud to God, cry aloud to God that he may hear me.
In the day of my distress I sought the Lord.
My hands were raised at night without ceasing; my soul refused to be consoled.
I remembered my God and I groaned. I pondered and my spirit fainted.
You with held sleep from my eyes. I was troubled, I could not speak.
 Psalm 76:1-5

The cold at night was unreal, everyone keeps you going. The Mass in the Basilica was the high point.
 Pilgrim

We kneel at the cross as a reminder that Christ redeemed us from sin and by his resurrection his spirit sanctifies us.

Walk six times around the outside of the large penitential bed (which comprises St Patrick's Bed and that of Ss Davog and Molaise), saying six Our Fathers, six Hail Marys and one Creed. Kneel at the entrance to St Patrick's Bed (near the men's hostel)

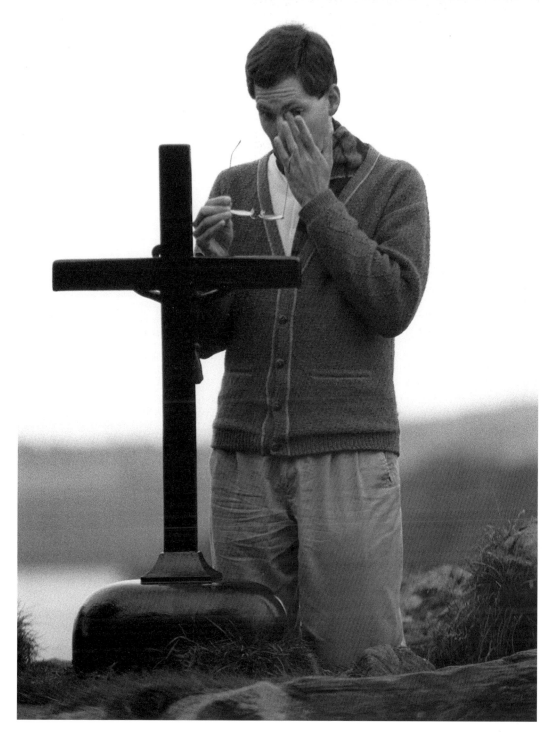

and say three Our Fathers, three Hail Marys and one Creed. Walk three times around the inside while repeating these prayers. Kneel at the cross in the centre and say them again. Kneel at the entrance to the Bed of Ss Davog and Molaise (nearer the water's edge) and say three Our Fathers, three Hail Marys and one Creed. Walk three times around the inside while repeating these prayers. Kneel at the cross in the centre and say them again.

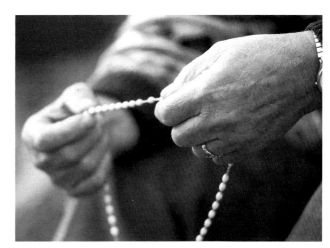

GO TO THE WATER'S EDGE

Save me, O God,
for the waters have risen to my neck.
I have sunk into the mud of the deep
and there is no foothold.
I have entered the waters of the deep
and the waves overwhelm me.
I am wearied with all my crying,
my throat is parched.
My eyes are wasted away
from looking for my God.
More numerous than the hairs on my head
are those who hate me without cause.
Those who attack me with lies
are too much for my strength.
How can I restore
what I have never stolen?

From Psalm 68, a cry of anguish in great distress

The beds provide an opportunity for praying in a very Celtic way – where touch and feeling and the earth, the body, and breath and uttered words are ways of expressing to God what is felt within. On these beds we fall to our knees, as an act of humility and sacrifice. In our diminished state we bow our heads and remember the suffering and humiliation Christ endured on this earth before he was crucified by his own people.

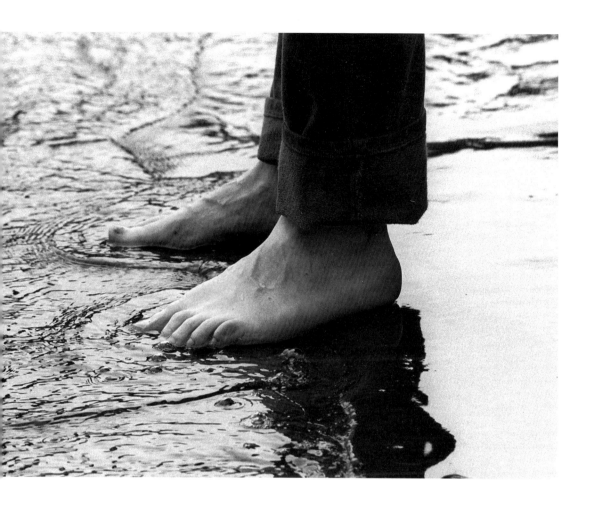

Go to the water's edge, and say five Our Fathers, five Hail Marys and one Creed. Kneel and repeat these prayers. Return to St Patrick's Cross; kneel and say one Our Father, one Hail Mary and one Creed.

The water is a reminder of Baptism and the commitment made to following the way of Jesus of Nazareth, who, by his life and death, saved the world. It is also therefore a reminder of the Red Sea and the Exodus and a hint of the slavery from which the pilgrim in those ancient and barbaric times was escaping from. The water of life, without which we would die, has its own mysterious qualities; like Christ it is immortal. As a power element it is both calming and treacherous; on the one hand it cleanses the soul and provides life, and on the other it causes destruction and death. It is a symbol of grace – from the waters of Baptism comes a new life from the Holy Spirit. This gift of grace is used when we make the Sign of the Cross. Like Christ it is everywhere, always ready to sanctify and renew our souls.

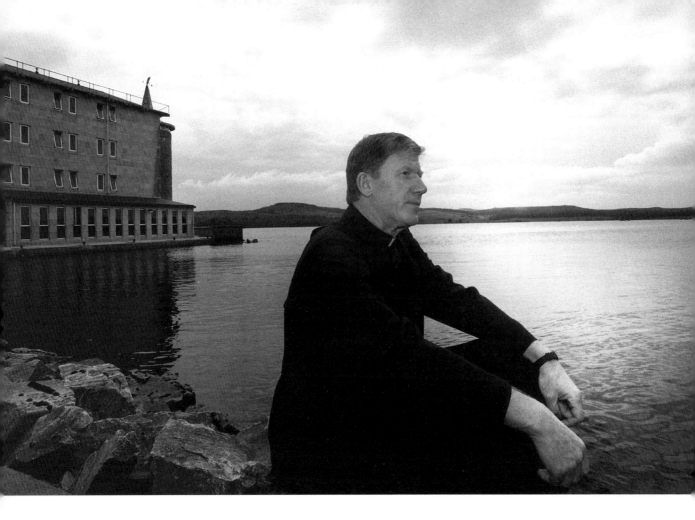

CHRIST BE WITH ME, CHRIST BEFORE ME, CHRIST BEHIND ME, CHRIST BENEATH ME

From St Patrick's Breastplate

Fr Richard Mohan has been Prior of Lough Derg since 1990. He had worked as assistant priest on Lough Derg each summer since 1974. His role is that of 'guardian of the sanctuary', attempting to ensure that the centuries-old tradition is maintained and that the island continues 'to meet the needs of people of all religions and none'. Fr Mohan is also leader of a pastoral team 'which works to provide liturgies and pastoral care for pilgrims. As Prior I am also administrator of the island and employer of staff'.

The linen room at Lough Derg is a busy centre, with hundreds of white sheets to be washed, dried and ironed. Linen is a significant symbol of purity and cleansing. White linen is placed on the altar under the body and blood of Christ at the Mass. It is worn by the priest during sacred ceremonies.

on into the night... and then the break of day...

If you give your bread to the hungry and relief to the oppressed, your light will rise in darkness, and your shadows become like noon. Yahweh will always guide you giving you relief in desert places. He will give strength to your bones and you shall be like a watered garden, like a spring of water whose waters never run dry.
 Isaiah 58:10-11

As dawn breaks over Lough Derg and the sun rises, it is so cold. We have prayed through the night. There is no end to the hardship on the island, the morning is almost a blur.
 Pilgrim

the vigil

10.15 p.m.	Introduction to the Vigil
11.45 p.m.	Rosary
12.30 p.m.	Fourth Station
2.00 a.m.	Fifth Station
3.30 a.m.	Sixth Station
5.00 a.m.	Seventh Station
6.30 a.m.	Morning Mass
8.30 a.m.	Sacrament of Reconciliation followed by the Eighth Station
12.00 noon	Renewal of baptismal promises
3.00 p.m.	Way of the Cross
9.20 p.m.	Night prayer and Benediction
10.00 p.m.	Retire to bed

Night-time has its own mystery, signifying the journey's end in the face of God, and in likeness to death where we surrender our life. As night approaches we surrender our day, a completion of our daily pilgrimage which is slowly laid to rest. Our hopes and fears join the ebb and flow of life's journey to salvation. Night brings its own fears – we are frightened of the dark, the unknown, there is no light to guide us on our way. As dawn breaks it signifies a new beginning; a new day has begun, and we are refreshed and renewed as we wake from our slumber. We leave behind the dread of night and look forward to the energy of this new beginning. We praise God for his creation as we offer ourselves to him for another day.

journey's end... the third day

Hail glorious Saint Patrick, dear saint of our Isle,
on us thy poor children, bestow a sweet smile,
and now thou art high in the mansions above,
on Erin's green valleys look down in thy love.
 ... trad., Hail Glorious Saint Patrick

Through Jesus, let us offer God an unending sacrifice of praise – a verbal sacrifice that is
offered every time we acknowledge his name. Keep doing good works and sharing your
resources, for these are sacrifices that please God.
 Hebrews 13:15-16

Conclude the Station in the Basilica by saying five Our Fathers, five Hail Marys
and one Creed for the Pope's intentions.

the third day

6.00 a.m. - Bell for rising
6.30 a.m. - Closing Mass
7.30 a.m. - Ninth Station
9.45 a.m. - Departure of boats

As the bells fill the morning air at Lough Derg, pilgrims come together for Mass.
The pilgrims complete the ninth Station. The physical hardship is almost at an
end. The soul and mind are renewed and cleansed. A thought must be given to the
Crusaders who, in the early centuries, made voyages to the ancient and holy sites
associated with the life and death of Christ, in order to feel part of the crucifixion
he suffered before his death. Bearing that in mind, the pilgrim is now ready to face

the world. The Prior accompanies the pilgrims to their boat, steering them away and, as everybody departs singing Hail Glorious Saint Patrick, another boat arrives with new pilgrims.

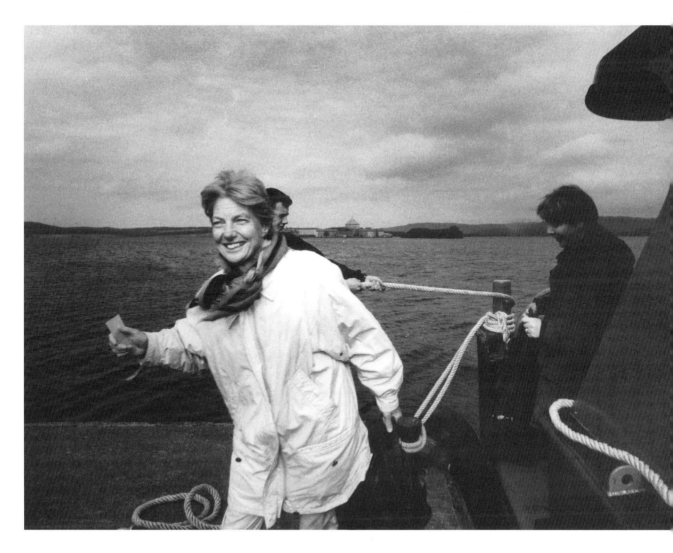

Chapter Four: **Sext – Sacred Signs and Symbols**

The Mass

The Eucharist is the summit toward which the activity of the Church is directed; at the same time it is the fountain from which all its power flows.
Second Vatican Council, *Constitution on the Liturgy,* 10

> *Once I am sure there's nothing going on*
> *I step inside, letting the door thud shut.*
> *Another church: matting seats and stone,*
> *And little books, sprawlings of flowers, cut*
> *For Sunday, brownish now; some brass stuff*
> *Up at the holy end; the small neat organ;*
> *And a tense, musty, unignorable silence,*
> *Brewed God knows how long. Hatless, I take off*
> *My cycle clips in awkward reverence…*

From 'Churchgoing' by Philip Larkin

praise the lord in his sanctuary

*We are only the earthenware jars that hold this treasure, to make it clear that such an
overwhelming power comes from God and not from us.*
 2 Corinthians 4:7

St Mary's Cathedral, Killarney, Co. Kerry was built during the famine years in Ireland
and was used as a shelter during the black year of 1846-47. It was designed by
Augustus Pugin, who found his inspiration in the monastic traditions of Innisfallen
island in Lough Léin, the lake of learning, where the Augustine monks wrote the
Annals of Innisfallen. In the Cathedral, signs and symbols of an ancient faith come
alive again in every celebration of the Eucharist.

In the celebration of the Eucharist we proclaim our faith. It is the summit of our
Catholic life. This celebration through sacred signs and symbols is a living
experience in which the gifts of bread and wine are transformed into the body and
blood of Christ. This wondrous gift brings together in union with Christ the
assembly gathered in his name.

The Eucharist is a remembrance – of that Last Supper which Christ shared with his
apostles, of his crucifixion and death, and of his glorious resurrection.

The Mass as we know it today derives its name from the Latin words *Ite, missa est*, the
sending forth of Christians at the end of the celebration to carry out Christ's mission
of love in our world today.

There are two parts to the celebration of Mass – the Liturgy of the Word and the
Liturgy of the Eucharist.

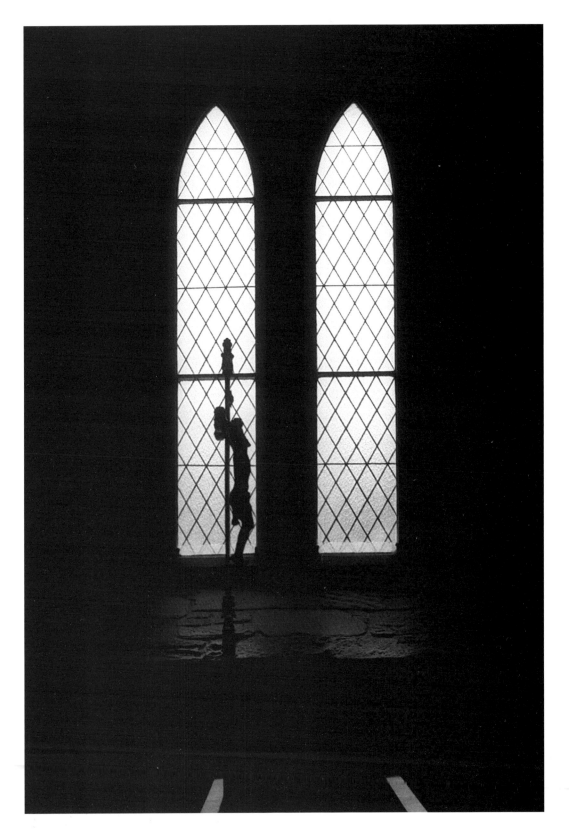

whose limbs were stretched on the cross

Jesus then came out wearing the crown of thorns and the purple robe. Pilate said 'Here is the man!'
John 19:5

King of the Friday
whose limbs were stretched on the cross.
Lord who did suffer
the bruises, the wounds, the loss.
We stretch ourselves
beneath the shield of thy might.
Some fruit from the tree of thy passion
fall on the night!
(from the Irish)

The cross is the universal symbol of Christianity, a vivid reminder of the humility of Christ's sacrifice and redemption for us. As an object of supplication it is venerated above all other signs and symbols. It has its place of honour in the sanctuary.

Making the Sign of the Cross sanctifies us for prayer and recollects our thoughts towards God, calling our mind and body together to meditate and become one with God. We end our prayer with the Sign of the Cross.

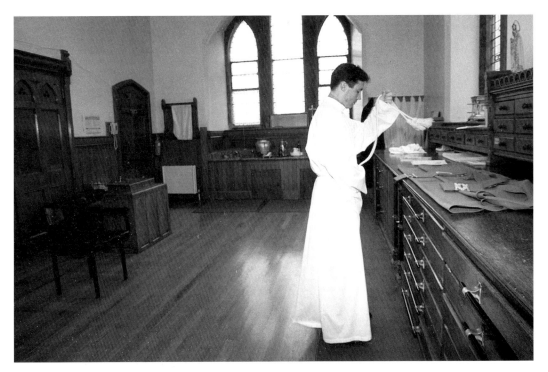

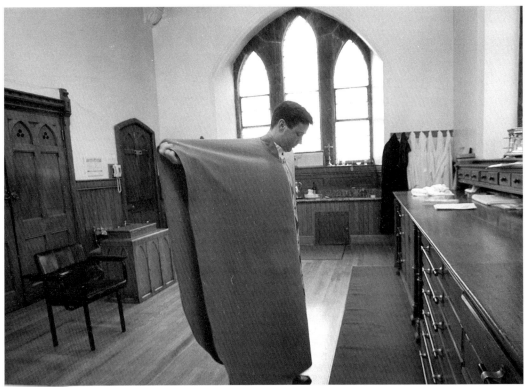

vesting for mass

Let no man be in the tabernacle when the high priest goes into the sanctuary.
Leviticus 16:17

Liturgy demands preparation. This in turn requires a specific preparation area – this is called the sacristy. (*Place of Worship* 9:1.) Vestments, linens, vessels and other liturgical wares are kept here. The liturgical ministers gather here for vesting, last-minute instructions and brief prayer.

The priest at Mass dons first the white alb, a reminder of the white garment of baptism, then the stole, a symbol of authority, and then the chasuble of the colour of the day. These vestments indicate the proper function of the wearer in the assembly.

preparing for the meal

Behold, how good and joyful a thing it is, brethren, to dwell together in unity!
Psalm 133:1

Tadgh Fleming has been sacristan at St Mary's Cathedral for thirty-six years. He is also Parish Clerk – 'My role is to prepare the altar for all church ceremonies and to record all baptismal and marriage celebrations in the parish.'

Here Tadgh puts into the ciborium or paten the breads necessary for the Communion of priest and people. These, with the chalice, will rest on the corporal, a square piece of linen. He fills the jugs with wine and water before placing all the objects as gifts ready to bring to the altar. In a quiet moment of reflection the priest and server stand together and recite the altar server's prayer before Mass:

Let us pray.
Come let us worship and bow down,
let us kneel before the Lord, our
Maker. Glory be to the Father…
God our Father. You have given us the
privilege of serving you at your altar.
Help us to be reverent and attentive
in your house. May we always think
of what we are doing and saying and
may we listen carefully to your word.
May we give glory to you and be
an example to others.
We ask this through Christ our Lord.
Amen.

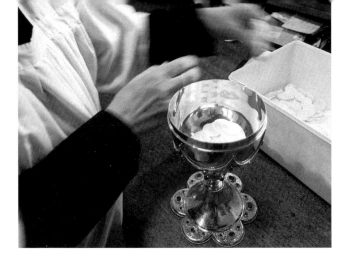

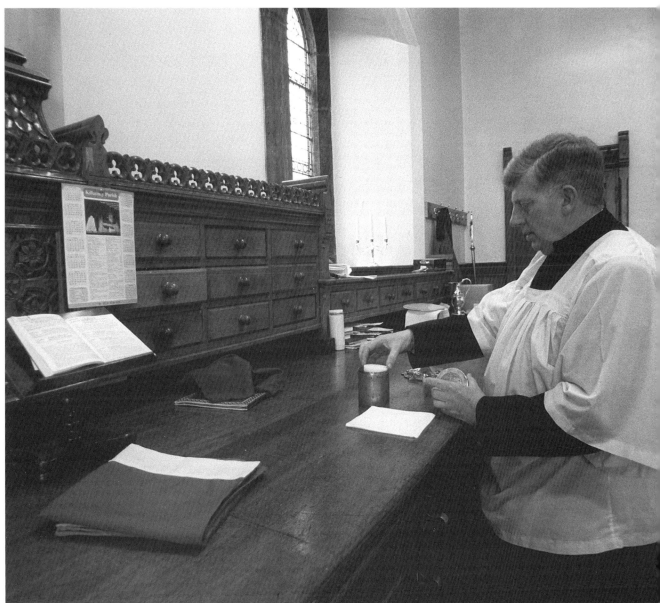

I will go to the altar of love

I would lead the rejoicing crowd into the house of God, amid cries of gladness and thanksgiving, the throng wild with joy.
 Psalm 41:5

The sacristan prepares the ambo for the Liturgy of the Word. The ambo is much more than merely a place from which to read. It is the table of the bread of the word, just as the altar is the table for the bread of the Eucharist. When the scriptures are proclaimed in the liturgy, Christ himself is speaking to his faithful and they are celebrating his presence in the word. (*Place of Worship* 13:2.)

The tabernacle is a sacred receptacle in which the Blessed Sacrament is reserved. The purpose of this reservation is to provide for communion of the sick and for adoration, both public and private. The eucharistic celebration itself is the true centre of the Church's worship, and indeed of the whole Christian life. The actual celebration of the Eucharist is the focus of the normal Sunday Mass, and the altar its centre. (*Place of Worship* 16.)

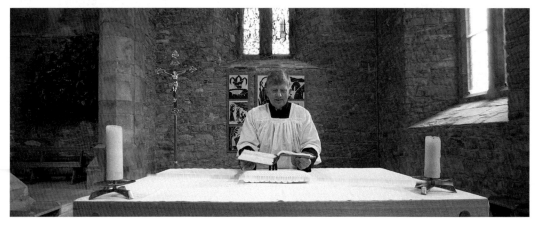

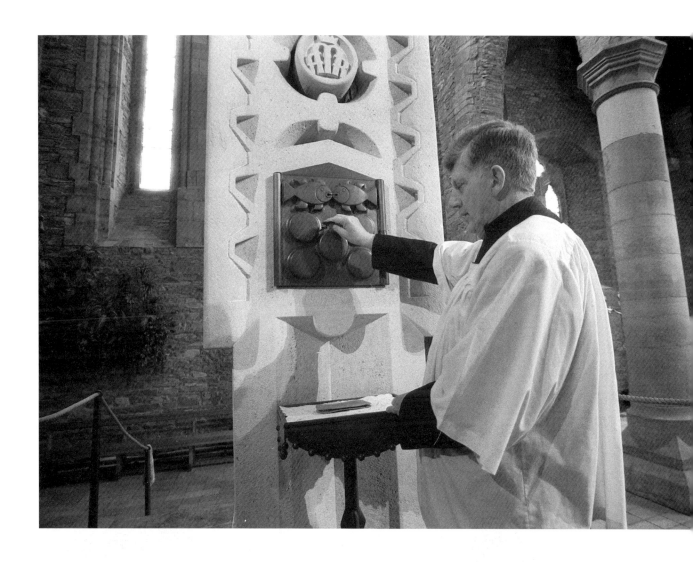

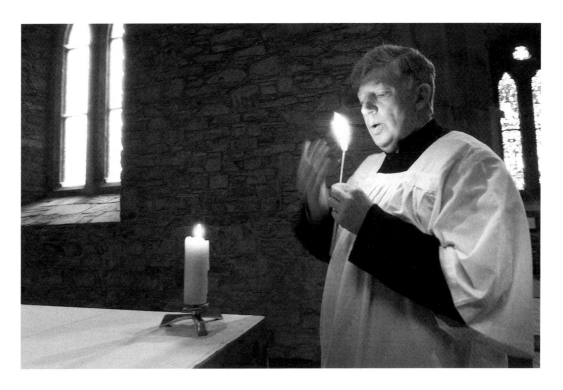

the people in darkness have seen a great light

The people who walked in darkness have seen a great light.
 Isaiah 9:2

Candles and oil lamps with their living flame are symbols of the risen Christ. They are reminders of our transformation from darkness to light in baptism. Candles are used during liturgical services to express devotion or the degree of festivity. The motion of the candle flame is calming and transfixing, creating an inner warmth for our souls. Candles express our ongoing invocation to God.

The Paschal Candle stands as one of the greatest symbols of the Church. At Easter it reminds us that by his resurrection Christ overcame the darkness and brought new life and hope into the world. After the Easter Season the candle should be kept with honour in the baptistery, so that in the celebration of baptism the candles of the baptised may be lit from it. In the celebration of funerals the Paschal Candle should be placed near the coffin to indicate that death is the Christian's Passover. In the season of Advent/Christmas, candles express the hope and joy in Christ's coming. The sacristan places the candles for Mass either on the altar or around it.

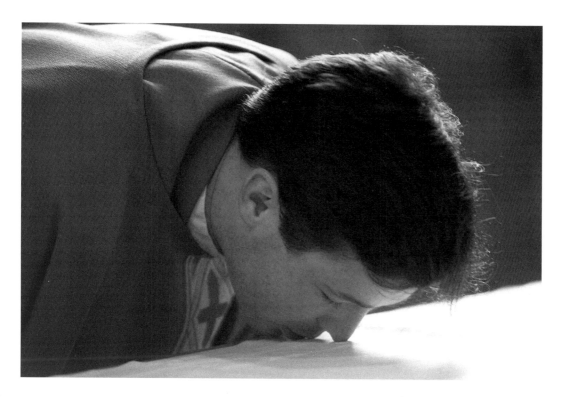

COME BEFORE ME AND REJOICE

You are my praise in the great assembly. My vows I will pay before those who fear him. The poor shall eat their fill. They shall praise those who seek the Lord.
Psalm 21:26-27

In the assembly of the people of God the one altar signifies the one Saviour Jesus Christ and the one Eucharist of the Church. The Christian altar is by its very nature both altar of sacrifice and table of the sacred banquet. It is the altar of sacrifice where the sacred mysteries are celebrated under sacred signs. It is also the table of banquet around which the faithful assemble to give thanks or eucharist to God and to share in the supper of the Lord. The altar should be treated with the greatest reverence. And since it is at the altar that the memorial of the Lord is celebrated and his body and blood given to the people, it is seen traditionally as a sign of Christ himself, a silent yet eloquent witness to his saving work which is perpetuated throughout the ages until he comes again. This is why the tradition of the Church can say: 'The altar is Christ' (*Place of Worship 14*). An altar made of stone is a further reminder of Christ our rock and cornerstone. Today, for the celebration of the Eucharist, there are placed only the bread, the wine and the book. Candles may be placed on the altar provided they do not block the view.

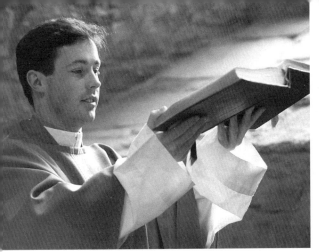
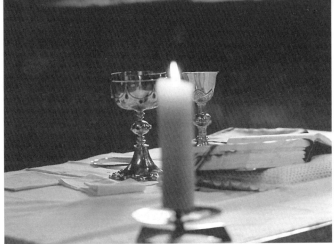

I serve with my spirit in the gospel of his son

God is love and anyone who lives in love lives in God and God lives in him. Love will come to its perfection in us when we can face the day of Judgment without fear: because even in this world we have become as he is. In love there can be no fear, but fear is driven out by perfect love.
I John 4:16-18

The Gospel is proclaimed from the ambo after the readings from the Old Testament and Psalms. The word gospel means 'good news' and is derived from the Greek and Latin root *evangel.* The congregation stand together to hear the Gospel – the words of Matthew, Mark, Luke and John.

Bringing the gifts of the spirit

For I am longing to see you, to strengthen you by sharing a spiritual gift with you.
Romans 1:11

The gifts of bread and wine are brought to the altar, marking the beginning of the celebration of the Eucharist. Then the priest invites the assembly to give thanks to the Lord, our God. We are called to make the act of remembrance, to bring to mind the suffering that Christ endured for us by his death on the cross and the glory of his resurrection, so that we too can live the mystery of the Eucharist by offering ourselves with Christ.

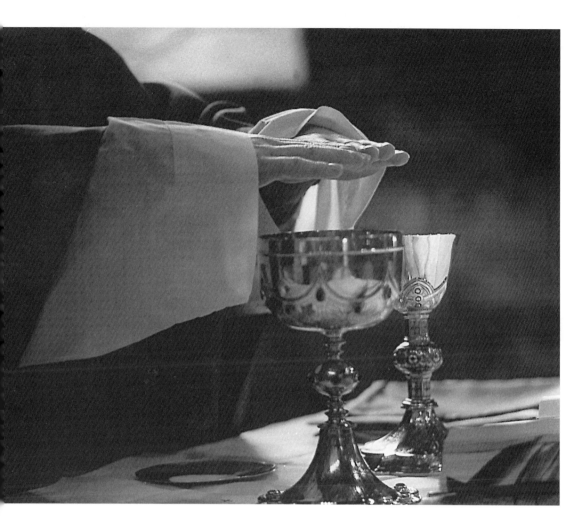

let your spirit come upon these gifts

In Christ were created all things in heaven and on earth: everything visible and everything invisible, Thrones, Dominations, Sovereignties, Powers – all things were created through him and for him. Before anything was created, he existed, and he holds all things in unity. Now the Church is his body, he is its head.

As he is the Beginning, he was first to be born from the dead, so that he should be first in every way; because God wanted all perfection to be found in him.

Colossians 1:16-19

The priest extends his hands over the gifts, calling on the Holy Spirit to transform them with the body and blood of Christ. This prayer is called an epiclesis. This ancient gesture is to be found in the celebration of all the sacraments.

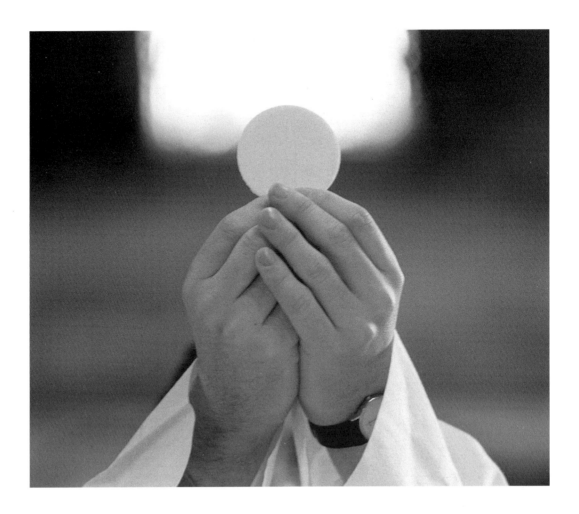

The great prayer of thanksgiving is also a prayer of consecration. In the recalling of the words of Jesus at the Last Supper the bread and wine become for us the body and blood of Christ. We remember the paschal mystery of Christ's death and resurrection and join in the offering with Christ to the Father of the perfect sacrifice. The Eucharistic Prayer ends with another burst of praise and the Great Amen. With the Our Father the Communion Rite begins. The Breaking of the Bread expresses our union in Christ, and the mingling of the bread and wine expresses the union of the body and blood of Jesus Christ. All are invited to the Table of the Lord.

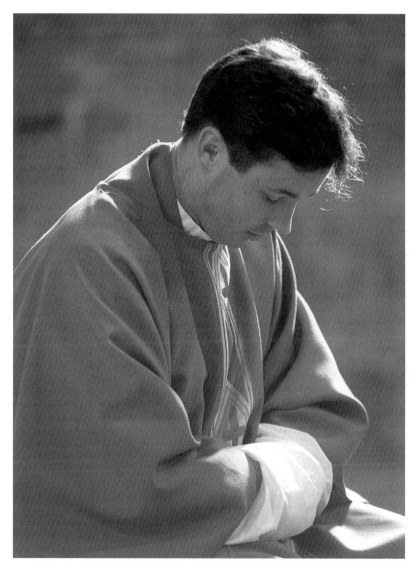

I am with you always

Sé an Tiarna m'aoire; ní bheidh aon ní de dhith orm. Cuireann se mo luí mé i móinéar féar ghlas; seolann sé i meall an uisce mé mar a bhfaighim suaimhneas.
 Salm 23

Fr Liam Lynch, ordained to the priesthood in 1996, is curate in the Killarney Parish. He realised he had a vocation at sixteen. 'There was only one life to live. I wanted to make the most of that life by helping others, and gradually I began to see priesthood not only as a call from God, but also as a ministry to help and be with people, to journey with them through life.'

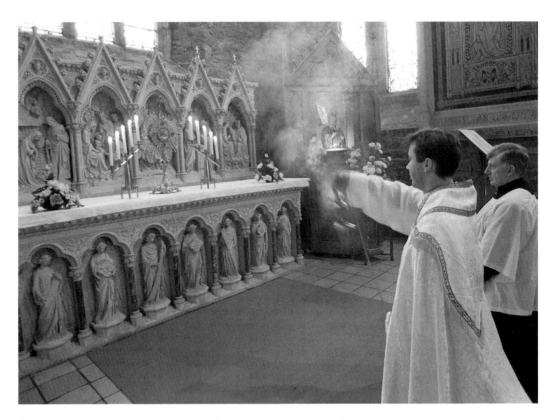

let my prayer be counted as incense before you

A pure heart create for me, O God, put a steadfast Spirit within me.
 Psalm 50:12

Incense makes the air we breathe visible. Like the rising of our prayers its aroma wafts from the thurible as the grains of incense are burned upon the charcoal. The fragrance pours out in reverence to the sacred objects.

In all religions incense has been used to convey the mystery and awe surrounding the Divine Presence. Here it is used at Benediction, but it is also used in all liturgical rites. Benediction is a service of exposition and adoration of the Blessed Sacrament, concluding with a blessing of the people with the sacrament.

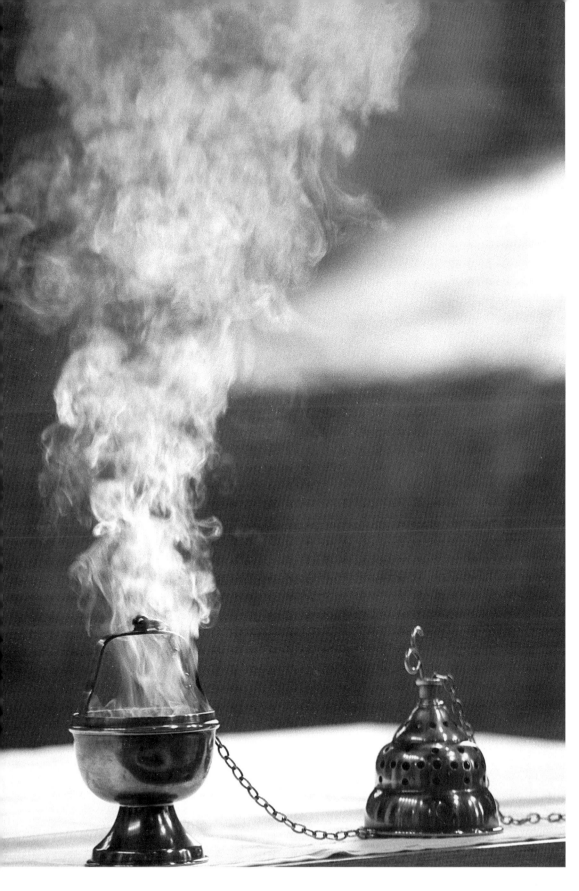

Chapter Five: **None – Artists and Artisans**

There was a time when only Churches commissioned artists to work.
Expressionist sculptor Imogen Stuart

st teresa's prayer

Christ has no body now but yours;
no hands, no feet on earth but yours.
Yours are the eyes through which he looks
compassionately on this world;
yours are the feet with which he walks
* to do good;*
yours are the hands with which he blesses
* all the world.*
Christ has no body now on earth
* but yours.*

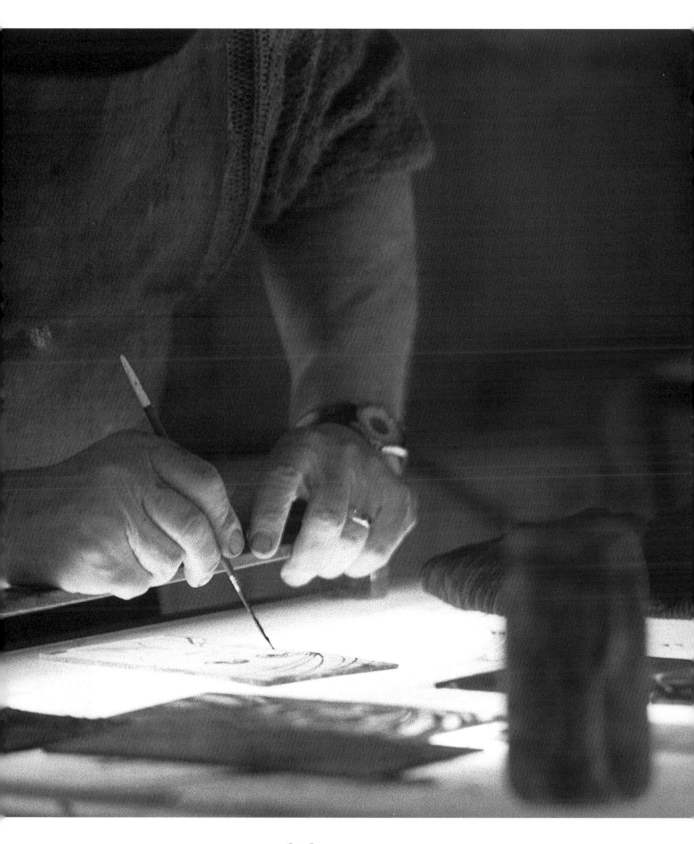

the artist at work

Your light must live in the spirit of men, so that, seeing your good works, they may give the praise to your Father in heaven.
 Matthew 5:16

Since the beginnings of Christianity church art has been the greatest source of inspiration, providing us with the perfect imagery to admire and pray to God. Through the centuries artists have made our worship more immediate, depicting stories and images from the Bible through the media of stained glass, frescoes, paintings, sculptures, woodcarvings and tapestries. The artist is inspired by the majesty and mysticism that surrounds the enigmatic work of God.

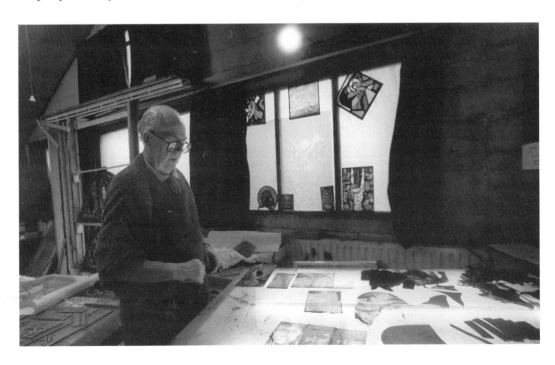

a tedious task ahead

I thank you for the wonder of my being, for the wonder of all your creation.
Psalm 138:14

The early churches had wonderful frescoes, and coloured glass wasn't used until the seventh century. The Cathedral at Augsburg has four twelfth-century windows depicting the four principal prophets, Daniel, Jonah, King David and Hosea. For those who could not read, these new representations of the scriptures were a means of giving praise to God. As light shone through the window to reveal the life of Jesus in all its glory, it evoked a sense of majesty for all those who believed.

Between 1903 and 1955 a group of Irish artists established an unqualified reputation for their stained-glass work all over the world. Stained glass up to this was dull and repetitive, but artists like Michael O'Connor, Michael Healy, Wilhelmina Geddes and, above all, Harry Clarke, brought great energy and new life into stained glass. Clarke brought the saints to life in his windows. In the Honan Chapel, Cork, he depicts the working saints of Ireland: Finbarr, Brendan and Ita. His celebrated Stations of the Cross are at Lough Derg Basilica, and he had other commissions in Tuam Cathedral, Knock, the Friary at Ballyhaunis, Belvedere College, Dublin, the Franciscan Friary, Killarney, St Vincent's, Fairview, Donnybrook and Dingle.

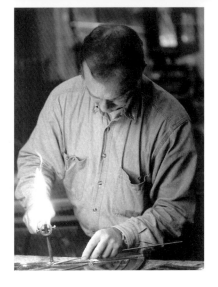

the workshop

*The work of each builder is going to be clearly recalled when the day comes. That day
will begin with fire, and the fire will test the quality of each person's work.*
 1 Corinthians 3:13

Founded in 1944, the Abbey Stained Glass Studio at Kilmainham in Dublin
specialises in ecclesiastical work. Meticulous care is needed for the restoration of
stained glass. Under the directorship of Ken and Muriel Ryan, nothing is left to
chance as every fragment of stained glass is lovingly restored by the craftworkers,
some of whom have been with the company for forty years.

Stained glass is a fragile material, battling constantly against the elements of
time and nature. Ken Ryan has found 'that stained glass windows have always been
too tightly fitted, both at the sides and top and bottom, with each panel fitted
immediately on top of the panel below, which does not allow for upward expansion'.
Much stained glass is exposed to the rays of the sun and, because of the dark colours
used, heat is attracted. The build-up of heat causes the lead to become pliable, the
weight makes the window sag and buckle, and, because lead does not revert to its
original shape, with each passing day the window sags further and becomes even
more distorted. 'Then it becomes necessary to take the window out completely,
dismantle the old lead, clean each glass and fit new lead throughout.'

a labour of love

*Again Jesus asked 'With what shall I compare the Kingdom of God? It shall be like this.
A woman takes some yeast and mixes it with forty litres of flour until the whole batch of
dough rises'.*
 Luke 13:20

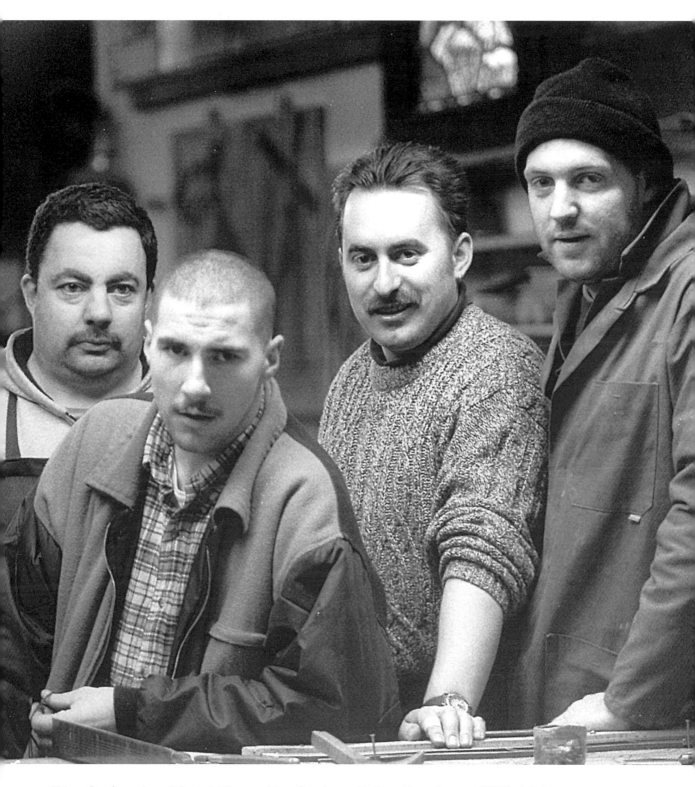

Abbey Craftworkers John McKeown, Ray Corrigan, Robert Gormley and Willie Malone

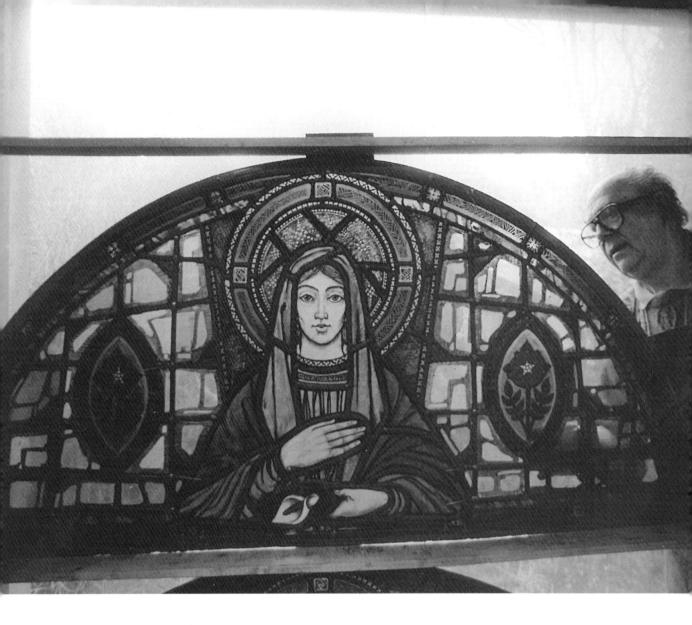

the Restoration process

Work is in progress on glass from the Franciscan Abbey in Kildare, and on a piece from Bandon Parish Church. The procedure is as follows:

Remove the stormglazing and replace it with new clear glass, using 6mm clear float glass to reduce the build-up of heat and allow for adequate ventilation at the base of the stormglazing. Remove the stained-glass windows and take them to the studios. Record each panel by taking photographs and making a full-size rubbing. Make an exact copy of the leads, dismantle the panel and place the fragments on a tray. Painstakingly clean and repair each piece of glass, and make moulds and templates. Reinforce and strengthen the joints and gently chip away the old hardened putty.

[90]

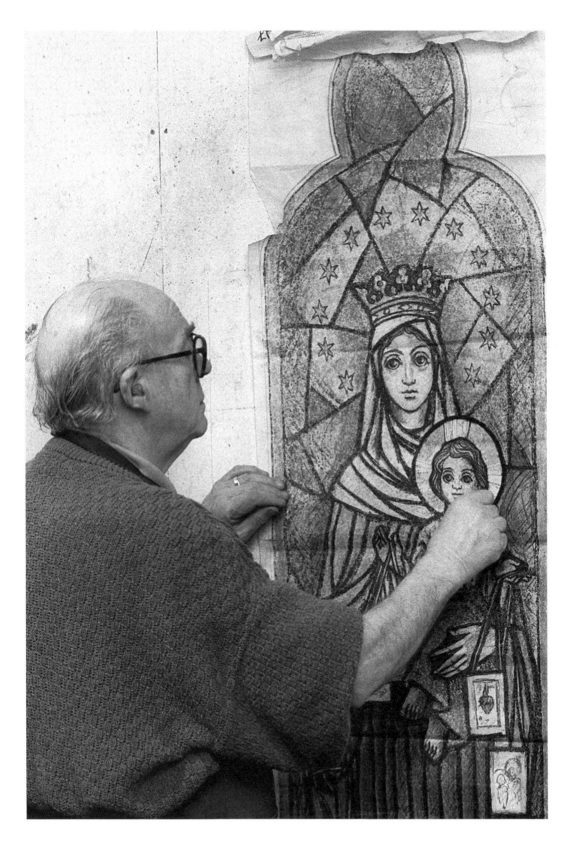

pαtieNce

A man takes a mustard seed and sows it in his field. The plant grows and becomes a tree, and the birds make their nests in the branches.
Luke 13:18

The intricacies of glass can often be tiresome, and the condition of the windows poor, yet the restoration is intensely satisfying. Resident artist Kevin Kelly has worked in stained glass since 1942. Being a stained-glass artist demands great flexibility. Because he is employed by a studio, Kevin seldom gets to see the finished product. Here he is photographed working on the early stages of an Immaculate Conception for Our Lady of the Sea Church in the Channel Islands.

After reproducing newly painted pieces to match the original, the glass is coated with a plastic solution to preserve the paintwork. This fixes the paint, protecting it from damage during the process of restoration and against future corrosion.

When the glass pieces have been replicated, all the old pieces of glass in the panel are cleaned, restored and plated. New leads are cut and fitted around the irregularly shaped glasses and soldered at the joints. The panels are then cemented, making the lead more rigid and waterproof. Once leaded up, the panel awaits the reinstallation of the window. The final in-studio task is to solder on copper tie wires to attach the windows securely to the new tie bars on site.

Denis Gleeson, like his father, works at the Abbey Studio. He works at the kiln where cement putty is forced into the lead and the paint is fused onto the glass. 'It's there forever more.'

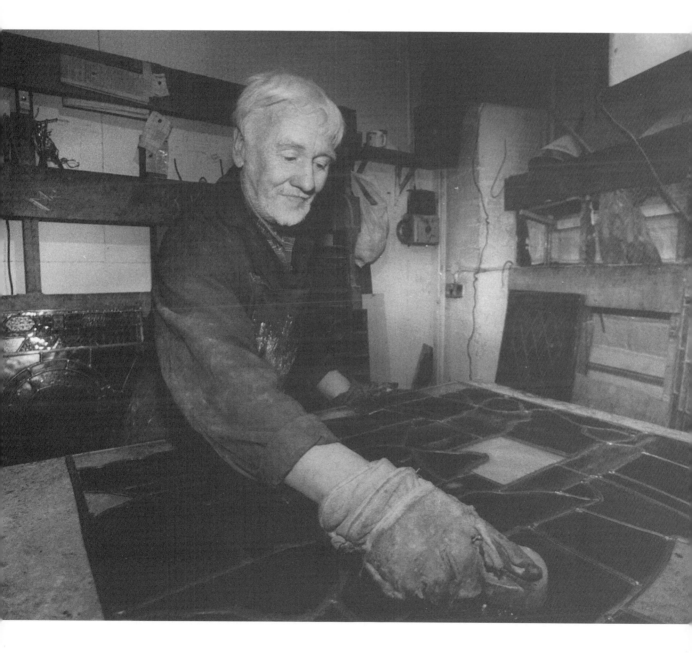

Singer Nóirín Ní Riain, Dromore, Co. Limerick

'to worship that celestial sound…'

Sing psalms to the Lord with the harp, with the sound of music. With trumpets and the sound of the horn acclaim the King, the Lord.
Psalm 97:5-6

The artistry and beauty of singing the liturgy of the Mass has always raised our spirits to God, enhancing the celebration of the Eucharist. Nóirín Ní Riain encapsulates this precious gift in all her being. Her music is wild and sensuous, and her mission is to sing and share her conviction. 'Singing for me is consolation – I love to sing, there is a power in spiritual music.' As a child she was deeply influenced by the beauty of the Gregorian Chant sung by the monks at Glenstal Abbey, and it became a part of her life. Nóirín has a very feminine and sensual approach to her chant. 'Chant is more suited to women's voices; it should be treated very preciously. Everybody's interpretation is viable, and it is as colourful as we all are.'

notes inspiring holy love

My song is of mercy and justice; I sing to you, O Lord.
Psalm 100: 1

Like the monks whose lives are punctuated by prayer and ritual, for Nóirín there is something hypnotic and punctuated about prayer, the notion of clicking into memory… 'the smell of incense as a child, my mother teaching us the various chants, the powerful hour of noon…. It is important to acknowledge these memories. We've inherited so much of the ritual, even the way we walk, our

[94]

ecclesiastical gait, the wonderful sense of being in your body.... Before I start my singing, I say "May every step be a prayer", and as I walk through the people singing, I say "May every note be a prayer". The idea of clicking into the spiritual gives tremendous comfort...to know you are being guided. Singing for me is very much connected to the spiritual.'

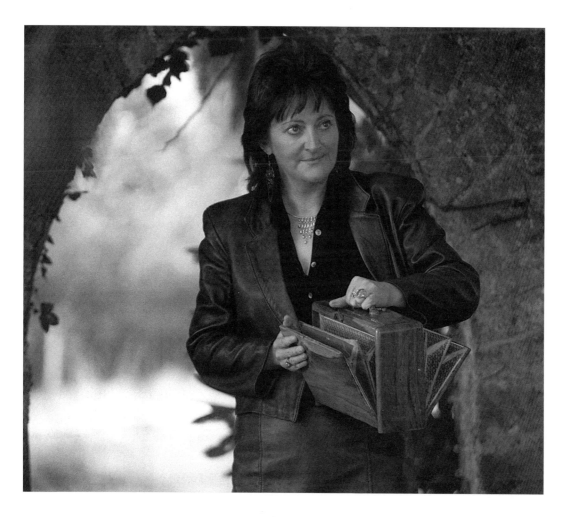

But oh! what art can teach, what human art can reach

O sing to the Lord, bless his name.
 Psalm 95:2

Nóirín interprets the Mass by using the notes of a musical scale. The first doh is the beginning of the pilgrimage, the act of actually going to Mass; the ray is the Liturgy of the Word, the welcome, the Confiteor, the readings, the Psalm; mi is the Gospel, the word of God, and the homily, the human word; fah is the preparation for the canon of the Mass; soh is the consecration, la the Great Amen, ti the Communion, and doh– the high doh, which is double the frequency – is the note we should go out on, 'the perfect song, the whole notion of completion'.

From harmony, from heavenly harmony

To you we owe our hymn of praise, O God, in Zion; to you we pay our vows, you who hear our prayer.
 Psalm 64:1-2

When Nóirín Ní Riain sings, the instruments become part of her. 'I have to feel them and know where they are at night, they are so close to me.' Nóirín chants with an Indian harmonium brought from India by missionaries. Its legs were cut down to ground level to humble the musician. The smaller instruments are called Shruti boxes – in Hindi *shruti* means musical interval. These are the singer's instruments, held against the diaphragm. 'I become the instrument, part of the spiritual; they become the performance. They are my vessels, my stole, my alb; I put them on before I start my ritual.'

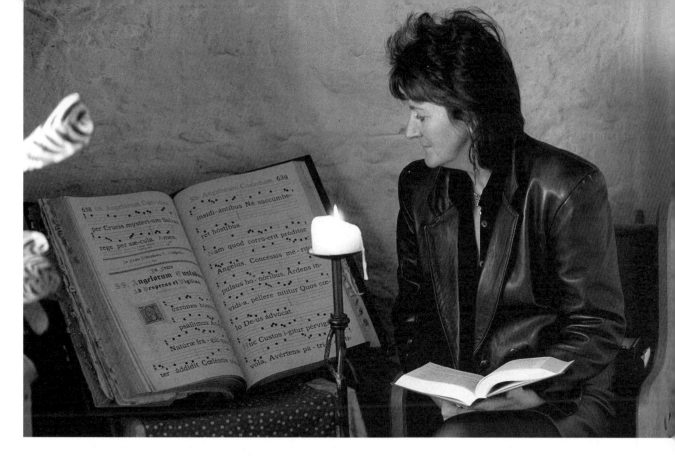

'Chant is singing from a space that is true to yourself…'

> *From harmony, from heavenly harmony*
> *This universal frame began:*
> *When nature underneath a heap*
> *Of jarring atoms lay*
> *And could not heave her head,*
> *The tuneful voice was heard from high,*
> *Arise, ye more than dead!*
> *Then cold, and hot and moist, and dry*
> *In order to their stations leap,*
> *And music's power obey.*
> *From harmony, from heavenly harmony*
> *This universal frame began:*
> *From harmony to harmony*
> *Through all the compass of the notes it ran,*
> *The diapason closing full in man.*

From 'Song for St Cecilia's Day' by John Dryden

Sculptor Imogen Stuart, Sandycove, Dublin

ın pensıve mood

I will give a white stone – a stone with a new name written on it.
 Revelation 2:17

Imogen Stuart describes her work as the 'universal creative profession'. She works with materials as diverse as wood, stone, bronze, steel, concrete, stained glass, plaster and clay. Encouraged in her native Berlin by the expressionist sculptor Otto Hitzberger, with whom she studied as a private student in Bavaria between 1945 and 1950, she came to Ireland in 1951. Even at this early stage, the influence of the Irish High Crosses could be seen in her work. She began to receive commissions from various churches here, and she acknowledges that at that time 'only the Churches commissioned artists'.

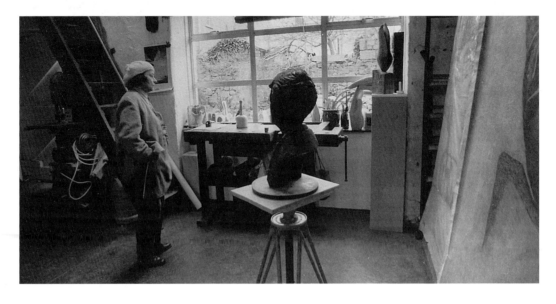

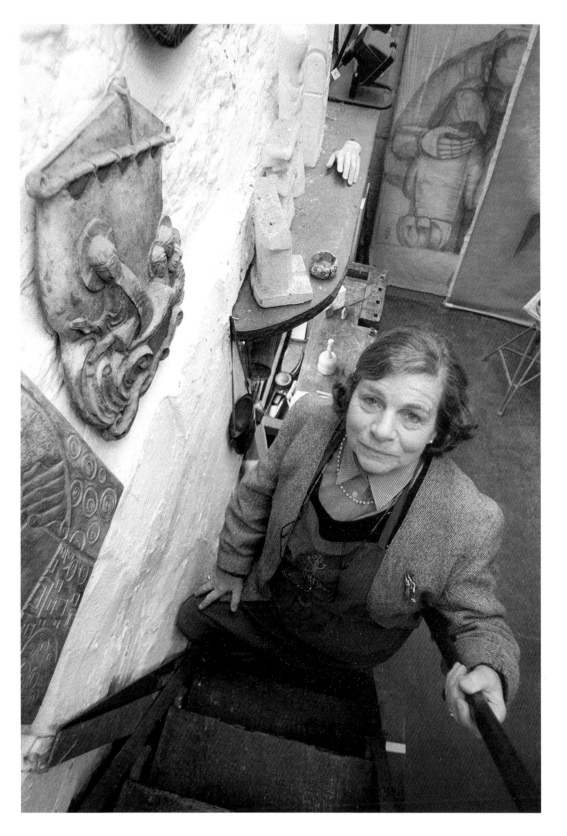

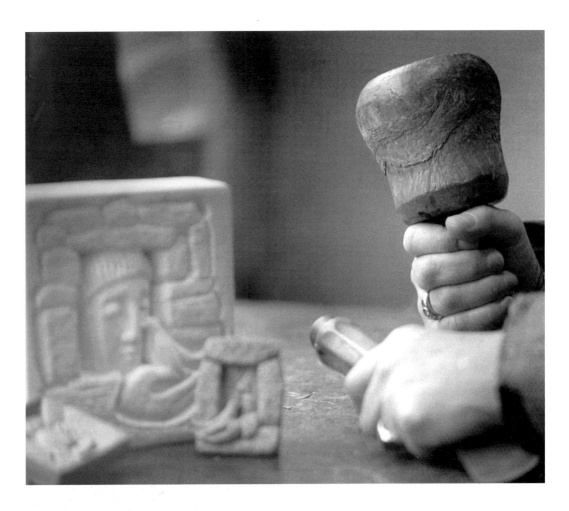

the artist at work

O Lord , How great are your works! How deep are your designs!
 Psalm 91:6

Imogen's love of God is evident in her work throughout Ireland and elsewhere. Her interpretations of the Madonna on the gable of Galway Cathedral, the Stations of the Cross at Curragh Camp Church, her woodcarving of the Holy Spirit at Longford Cathedral, the sanctuary furniture in Belvedere College, President Childers' grave, represent a mere fraction of her work which is to be found in every corner of Ireland. On a monumental scale Imogen excels: her six-foot bronze of Pope John Paul II with two children, commissioned in 1987 for the new library at Maynooth College, Co. Kildare, demonstrates her sincerity and integrity and her 'love of life and of work'.

I have carved you on the palm of my hand

O Lord, my rock, my fortress, my saviour. God, you are the rock where I take refuge.
Psalm 18:3

Though her style is rooted in the gothic, romanesque and baroque traditions, Imogen's approach is intuitive. Here she holds a scale model of the 'Arch of peace' which stands twelve foot high in the market square in Cavan. Her attention to shape and form clearly shows her empathy with people, nature and, above all, in her own words, 'a love of life, a knowledge of the craft, the sophistication of a past generation and a symphony of beauty and spirit…'

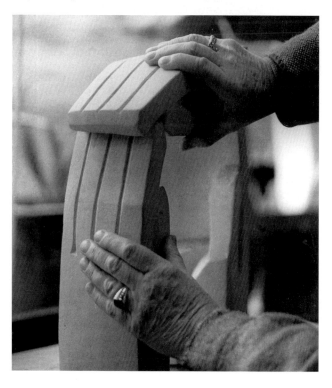

Frances Biggs, Galway

ᴡᴀᴛᴇʀ ɪꜱ ᴍʏ ꜱᴏᴜʀᴄᴇ ᴏꜰ ɪɴꜱᴘɪʀᴀᴛɪᴏɴ

And God's Spirit hovered over the water.
Genesis 1:2

Like the waters of the River Corrib Frances Biggs' creativity flows with colour and vibrancy. She works with such media as water colour, pastel, charcoal, tapestry and stained glass. Her first passion was music – she was a violinist with the ʀᴛᴇ́ Symphony Orchestra – and it was her late husband, sculptor and letter-cutter Michael Biggs, who first encouraged her to paint. 'I attended the College of Art and, after my first exhibition, achieved recognition as a religious painter.' Sacred and biblical imagery always appealed to her. 'There was so much mysticism attached to it... my imagination flowed rapidly onto paper.'

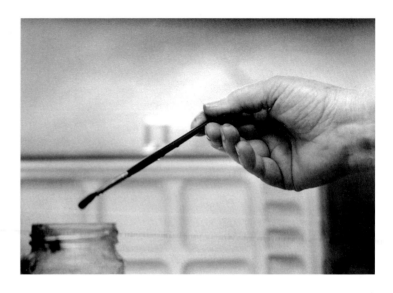

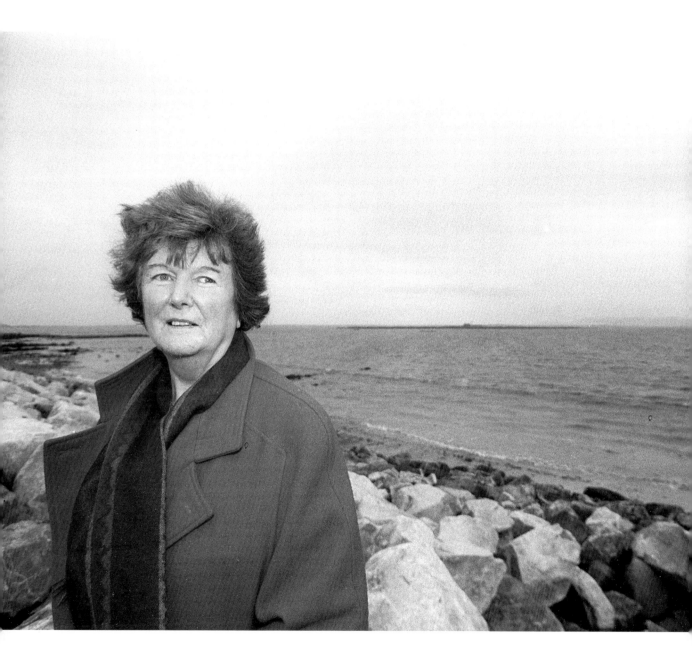

one of my favourites is john of the cross

O sing to the Lord, make music to his name, make a highway for him who rides on the clouds.
 Psalm 67:5

Michael Biggs became very involved in church work following the changes in the liturgy introduced by Vatican II. He received many commissions for sanctuary furnishings and design, and soon he and Frances began working together as a team. Renmore Church in Galway was their first joint commission, followed by Gonzaga College Chapel in Dublin. Their most celebrated work is in St Macartan's Cathedral, Monaghan, where Michael redesigned the sanctuary and carved the altar, ambo, lectern, etc., while Frances designed the vestments and tapestries and painted the Stations of the Cross.

Frances likes to work 'with abstract ideas; you can find your own mysticism in the Psalms'. She derives much of her inspiration from meditating on the different themes on which she is working. She finds that this helps in the research, as the artist would often become one with the subject. 'I love the writings of the mystics. One of my favourites is John of the Cross.'

for the love of god

But patience too is to have its practical results so that you will become fully-developed, complete, with nothing missing.
 James 1:4

Frances describes herself as a colourist. 'I have a deep love of colour; I use colour to give me a closeness to everything….' She uses powerful purples and blues, often seen as sacred and spiritual colours, richly represented in the life and passion of Christ. This vibrancy is evident in her tapestries and stained glass. 'Tapestries give me tremendous freedom to use colour, and the play of light on stained glass is immensely important to me…the work I do is a statement to God that I can't express in words.'

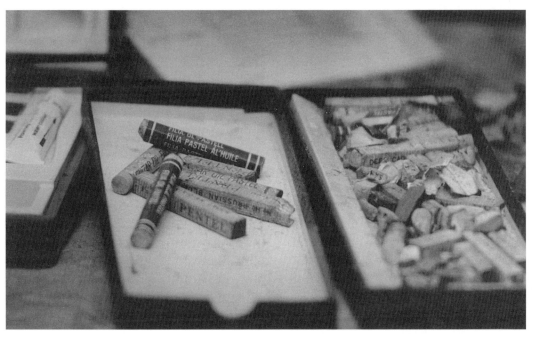

Bill Bolger, Dublin

a picture says a thousand words

O Lord, you search me and you know me, you know my resting and my rising, you dis-cern my purpose from afar. You mark when I walk or lie down, all my ways lie open to you. Before ever a word is on my tongue you know it, O Lord, through and through.
 Psalm 138:1-4

Bill Bolger is head of the Department of Visual Communications at the National College of Art and Design in Dublin. Twenty-five years ago he was invited by the newly formed Catholic Communications Institute of Ireland to produce the artwork for a new catechetical programme for primary schools. 'Hundreds of pictures and dozens of books later, I am still involved in the programme which is now in its third presentation.'

aquire print...

He guides me along the right path; he is true to his name.
 Psalm 22:3

'Outside teaching, most of my work revolves around books – designing them, illustrating them…and reading them.' This art form requires an ability to sense the mood and feeling of the author and reflect it in the design. It is often the hand of the designer that captures the attention and draws it well beyond the cover and into the heart of the book. Artwork used to be produced using pen and ink, gouache, watercolour, pastel, acrylic paint and photography, but now, though these media are still in use, most artwork is produced using computer technology. The old printing presses and woodletters are long gone. The artist's hand now operates a mouse and most images are scanned onto computers.

command z...

And it is plain that you are a letter from Christ, drawn up by us, and written not with ink but with the spirit of the living God; not on stone tablets, but on the tablets of your living heart.
 2 Corinthians 3:3

This combination of type and digital imagery has been enjoyable for Bill. 'Coming to grips with this new technology in middle age was an interesting challenge.' Sixteen years ago the first portable computer was bought for the College. 'It was the size and weight of a large, full suitcase, but it was magic, and I have been intrigued by the machines every since.'

 Like any artist, Bill Bolger starts with a blank page/screen. What emerges is astonishing and, when printed, bounces off the page. 'It's a new kind of artwork.'

Chapter Six: **Vespers – Education**

I walk through the long schoolroom questioning;
A kind old nun in a white hood replies;
The children learn to ciper and to sing,
To study reading-books and history,
To cut and sew, be neat in everything
In the best modern way – the children's eyes
In momentary wonder stare upon
A sixty-year-old smiling public man...

Plato thought of nature but a spume that plays
Upon a ghostly paradigm of things;
Soldier Aristotle played the taws
Upon the bottom of a King of kings;
World-famous golden-thighed Pythagoras
Fingered upon a fiddle-stick or strings
What a star sang and careless Muses heard:
Old clothes upon old sticks to scare a bird.

From 'Among School Children' by William Butler Yeats

Religious orders have long been associated with education thoughout Europe. In the Middle Ages Pope Gregory VII set standards for the clergy: priests had to be educated, they could no longer marry and had to obey their bishop. The standard of clerical education was raised, and the bishops began to organise the priests to live and work together in universities. It was this education of priests in Church institutions that set them apart at a time when few people could read and write. However, it must be remembered that in the centuries prior to Gregory's papacy, in the Dark Ages, the monks who roamed Ireland and Europe with their wealth of learning and skill were the true educators. Their legacy has lived on for fifteen hundred years.

Clongowes Wood College, Naas, Co. Kildare

ad majorem dei gloriam

Let the wise listen and they will learn yet more, and those of discernment will acquire the art of guidance.
Proverbs 1:5

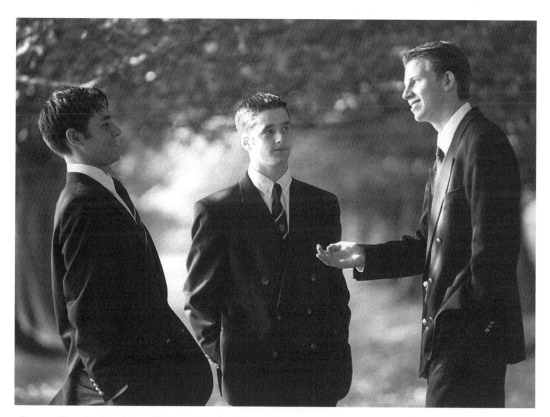

Owen Brady, Dublin, Simon Burke-Kennedy, London, and Mark Healy, Dublin

Set in a glorious secluded woodland in Co. Kildare, a remnant of the glory days of education in Ireland, with all its cultural ethos and traditions, Clongowes Wood College was established in 1814, before Catholic Emancipation, to help in the education of an Irish middle-class Catholic leadership in Ireland. The school has maintained its original ethos in spite of almost two centuries of complex social and cultural change in this country. This strong ethos is pursued in the uniquely favourable conditions of a boarding-school community, with students drawn from all over the country and elsewhere across the globe. Among the distinguished pupils who have attended the school are James Joyce, Archbishop John Charles McQuaid, Justice Kevin O'Higgins, former Taoiseach John Bruton, U2 manager Paul McGuinness. Most of the pupils go on to third-level education and have a high profile in the legal and medical professions.

ƌocenƌa ƌiscimus

The faithful all lived together and owned everything in common.
 Acts 2:44

The Jesuit ideal is 'to find God in all things', to be contemplatives in action. The Jesuits aim to teach the values of the Gospel and the Kingdom of God, and what St John calls 'the world', and 'to equip themselves and those with and for whom they work with the strength and wisdom to engage in the struggle for faith and justice in the world which is the work of the Gospel'.

Fr Conor Harper with a Leaving Certificate French Class

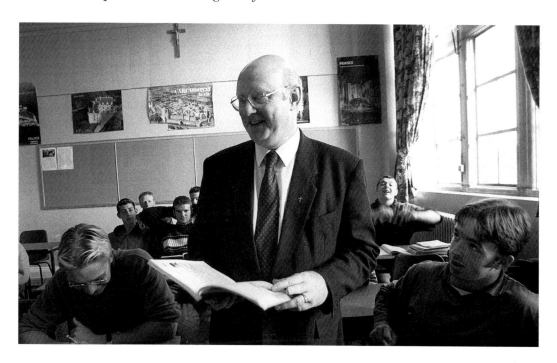

quot homines tot sententiae

And he changes the times and the seasons: he removes kings, and sets up kings: he gives wisdom to the wise, and knowledge to those that know understanding: he reveals the deep and secret things: he knows what is in darkness, and the light dwells with him.
 Daniel 2:21-22

The Jesuits particularly have tried to continue to develop the classical tradition of education, as transformed by Christianity, with its focus on the person as the centre of concern. This tradition was originated by the Greeks and Romans and 'baptised' by the Church. According to its tradition, Jesus Christ is the model of all human formation and the ideal towards which authentic education should strive. Jesuit schools in Ireland seek to embody this ideal in a variety of sectors — in the comprehensive and voluntary sectors, in day and boarding-schools.

Fr John Looby, Fr Kieran Hanley and Fr Conor Harper

vigilante et orate

Remember before God our Father how you have shown your faith in action, worked for love and persevered through hope, in our Lord Jesus Christ.
 1 Thessalonians 1:3

Fr Bruce Bradley is Headmaster at Clongowes Wood College. 'I act as chief executive of the school on behalf of the Board of Governors, and lead the school in all its activities according to the ideals set out in the charter of all Jesuit schools.' Fr Bruce lives his life as a true witness of God. In his role as headmaster he looks to the parable of the Prodigal Son in Luke 15 and the story of the woman taken in adultery in John 8. In Luke 15 Jesus portrays the Father as unconditional love, overwhelming his errant son with his mercy and fatherly understanding. In John 8, Jesus himself embodies this love and understanding in his dealings with the woman. In both accounts, God is overwhelming mercy. 'These images sustain me in my life and in my work; this is the God I try to introduce to my pupils and the one I know I am called to reflect in my dealings with them and with whomever I encounter.'

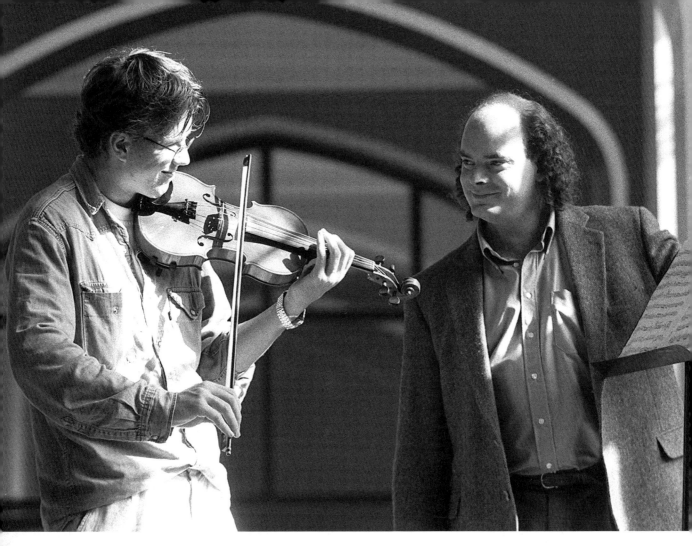

ERRARE EST HUMANUM

All that is good, everything that is perfect, which is given us from above comes down from the Father of all light; with him there is no such thing as alteration, no shadow of a change.

 James 1:17

Music is an important part of the Clongowes tradition. The school has its own orchestra/band and choir and twice-yearly concerts display the boys' talents. Violinist and teacher Philip Thomas, himself a past pupil of Clongowes, takes fifth-year David Lennon for a lesson: 'The confidence, knowledge of life and spirit of love that the teachers at Clongowes Wood gave me will always remain embedded in my mind and will continue to grow in my heart. Their encouragement and their willingness to help me on my path as a musician will never be forgotten. I suppose the true testament to their philosophy is that I'm back teaching here.'

The school choir is under the directorship of Elizabeth Keighary. James Flahavan, Richard Whelahan, Stephen Kearney, Christian O'Shea, Andrew O'Callaghan, Cian O'Driscoll, Michael Shiel, Liam Kidney, David Cunningham, Mark Healy, Simon Burke-Kennedy and Owen Brady are among the choristers.

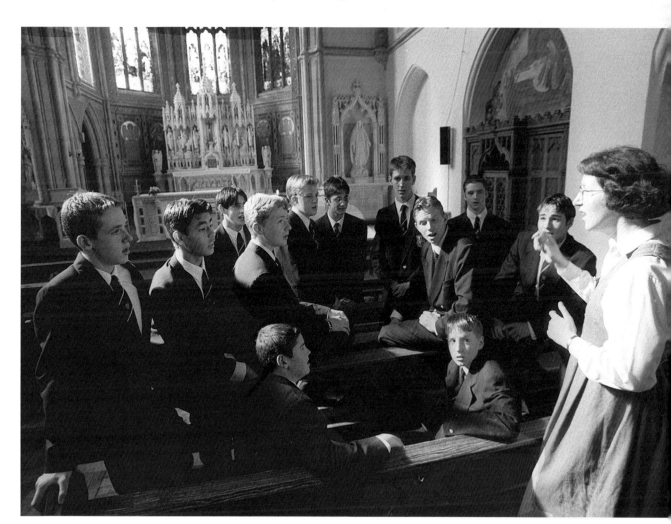

Buen principio, la mitad es hecha

Show me, Lord, your way, so that I may walk in your truth.
 Psalm 85:11

There are thirty-five teachers and 426 pupils at Clongowes. The extra-curricular activities form the basis of a real education for life: as well as the normal school subjects, the boys engage in debating, dramatics, social awareness programmes, spiritual guidance, heritage studies and, most importantly, sport, with a strong tradition of rugby, Gaelic games, cricket, tennis and soccer.

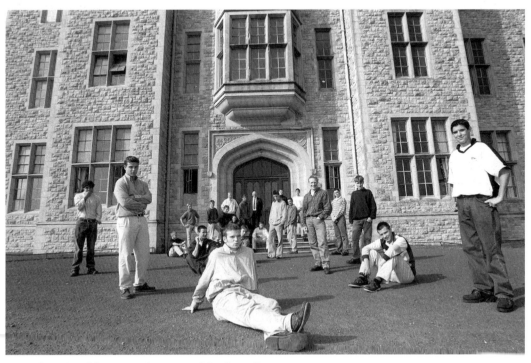

Leaving Certificate students outside the college

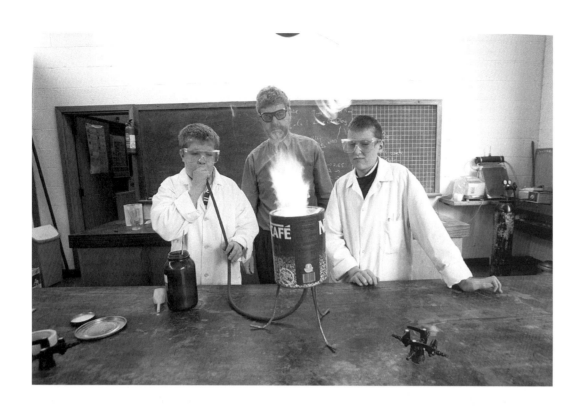

honor virtutis praemium

I have opened in front of you a door that nobody will be able to close and I know that though you are not very strong, you have kept my commandments and not disowned my name.

Revelation 3:8

Rugby is the celebrated sport associated with Clongowes Wood. The hundreds of acres of school grounds provide an ample nurturing ground for the development of the sport. The school boasts a fine record in the Leinster Schools Senior Cup, having won it no less than five times. 1998 was one of those marvellous years when they beat Terenure College by 37 to 18 in the cup final.

The Nagle Rice Project, Cork

If I could,
I'd give every child
A terrestrial globe....
If possible, even
A globe that would light up,
In the hope
Of opening those young eyes
As wide as they will go....

'These words of Dom Helder Camara, quoted in the Presentation Sisters' Education statement of 1982 were a gentle challenge to me in the eighties, as was the Christian Brothers' Chapter in 1989 in which I had a small role: "We question ourselves, our institutions, our priorities, our motivations, our assumptions. We challenge our world, the injustice that destroys, the competitiveness that breeds lust for power, the power that corrupts." (St Helen's Province, Chapter 1989)

Many questions came to mind in the two years I spent on the course organised by Brother Matthew Feheney (Presentation Brother and CFRC Director). Then, in 1993, I was invited to head up a project for the three congregations. Our aim was to discover what was being done by creative teachers to touch and enthuse young people, particularly those who were struggling in the system, and to spread the good news and the good practice. In 1994 we came across the Multiple Intelligence framework of Howard Gardner. This enabled us to recognise a broad range of talents in the students. It made sense of the many different approaches that teachers were using and it indicated teaching and learning strategies that enabled students to approach their learning from a position of strength. However, because it requires a change of role for the teacher, and a focus on process as well as content, it is a challenging approach.

Anne Fleischmann is a secondary school teacher, and has been Co-ordinator of the Nagle Rice Project since its inception in Cork in 1993 .She has brought the project beyond the wildest dreams of all concerned. It is her dynamic approach, dedication, and belief in the project that has instilled in the pupils an absolute joy and confidence that will surely bring them over the threshold of life.

Edmund Rice and Nano Nagle met the needs of the young people of their day by enabling them to achieve entry into education; the challenge today would seem to be to enable young people to gain real intrinsic benefit from the education on offer. The project is one small initiative by teachers, students and parents in Dublin (through the Marino Institute) and in Cork. Like the SPICES programme of the Presentation Brothers in St Lucia, it aims at the social, physical, intellectual, creative, emotional and spiritual development of youth, in an atmosphere of mutual appreciation. It was an aboriginal Australian woman who said: "If you have come to help me you've wasted your time, but if you have come because your liberation is bound up with mine - then let us work together."

Our hope is that teachers, parents and students will continue to seek out and celebrate their God-given strengths and intelligences, and explore together how these can best be developed and used as effective gateways into the learning that is required by the school programmes.'

Anne Fleischmann

laughter is the best medicine

Happy the people who acclaim such a God, who walk, O Lord, in the light of your face.
 Psalm 88:16

There is no limit to our intelligence. It was once felt that we were born with a fixed level of intelligence. Now we are learning that there is no end to our potential. Intelligence is now regarded as a multiple reality that occurs in different parts of the brain/mind systems. It is thanks to people like Dr Howard Gardner, with his discovery of at least eight intelligences, that we are enabled to identify the strengths and abilities in everyone. This brings special hope to those whose gifts were not recognised by the education system, except in peripheral or specialist areas.

We explore Gardner's eight intelligences theory through the work in hand at the Nagle Rice project, seeing how it has enhanced and enriched the lives of the pupils, engaged the teachers, fostered hope and encouraged parents' involvement in the development of each child.

With the pupils, teachers and their co-ordinator Anne Fleischmann, in three schools in Cork, we celebrate this creative project through the eyes of the pupil in true multiple-intelligence style.

The eight intelligences are: intrapersonal, interpersonal, visual-spatial, musical-rhythmic, bodily-kinesthetic, logical, verbal-linguistic, naturalist.

let the chilDRen come

*As soon as Jesus was baptised he came up from the water, and suddenly the heavens
opened and he saw the Spirit of God descending like a dove and coming down on him.*
 Matthew 3:16

We visit the pupils at the North Monastery Christian Brothers, Cork. The focus
here is the intrapersonal intelligence, a discovery of their own thoughts and
feelings. This is presented in a portfolio for their Confirmation. The sixth-class
pupils explore what is important to them, a practical self-awareness programme – in
their project they tell what happened in the world the year they were born; they give
the meaning of their names; each pupil organises a class reflection, finds out the
activities in his parish and discusses the role of Jesus in his life.

Howard Gardner is exploring the spiritual dimension as a possible ninth intelligence.

*Included in the picture with Co-ordinator Anne Fleischmann are Brian Cummins, Brian
Batt, Donnacha Twomey and Timothy Batt.*

lá fliuch atá ann

Unless you change and become like little children, you will never enter the kingdom of heaven.
 Matthew 18:3

The focus here is the visual-spatial intelligence – the pupils are exploring a story in the visual sense. Teacher Brendan Walsh explains the story on the blackboard, the children express what they mean visually, and create a three-dimensional representation. The pupils thrive on this involvement. Jason Healy, fifth class, says: 'It helps me remember the meaning of the story; pictures make the words and they make the sentence.'

Patrick Hogan explains his maths drawing …in his own unique way!

a helping hand

They helped everyone; and everyone said to his brother, 'Take heart!'
 Isaiah 41:6

The emphasis here is interpersonal intelligence, where pupils learn through person-to-person interaction. This helps them to understand, empathise and work as a team. Paired reading helps the pupils gain confidence in themselves – one motivates the other. Nioclás Ó Briain and Greg Ó Cathasaigh work together. Nioclás explains: 'If you work on your own, you get bored. It's nice that someone can help you out if you get stuck on a word.'

Interpersonal intelligence involves a heightened ability to negotiate and share points of view. Group role-play allows the children to explore this important skill.

all together now

All peoples, clap your hands, cry to God with shouts of joy!
 Psalm 46:1

The focus here is bodily-kinesthetic intelligence, a communication through body language. Third class teacher Denis Burns explains a maths problem with this intelligence, aimed at pupils who work well with their hands and impart their knowledge more easily by means of physical contact with the subject.

Learning vowel sounds comes alive using this approach. Here, David Barrett, Wayne Hourigan and Jason Cronin show the class just how it's done.

[126]

on the count of three

O praise him with resounding cymbals: praise him with clashing of cymbals.
 Psalm 150:5

Musical-rhythmic intelligence is a versatile intelligence enabling students to identify sounds and patterns which achieve a visible effect. Using rhythm and song, they learn facts like the months of the year or the EU member-states to a beat that is easy to remember. A rap rhythm tends to work well with the pupils who live in a musical culture.

Above: Alan Mooney and Ken Buckley play the tin whistle, Mark Moynihan and Gerard Brady intensify the beat.

budding performers

Praise him with timbrel and dance: praise him with strings and pipes.
 Psalm 150:4

In Scoil Críost Rí, Cork, first years, with their teacher Daithí Mac Comhaill, have composed their own rap, acted out the play, and used most of the multiple intelligences in achieving their goal.

Stiofán Ó Conchúr, with his classmates, who performed the African folk rap 'Jump like a chicken!'

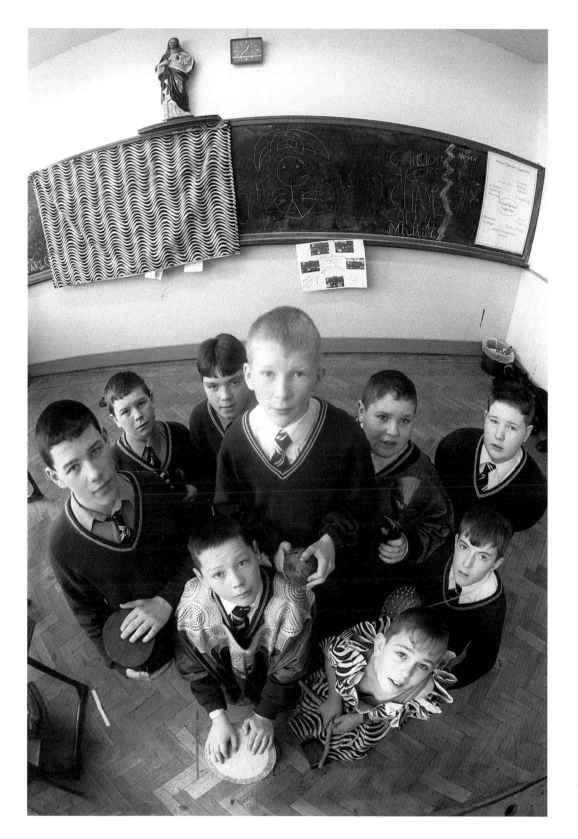

and in their silence

A time to keep silence; and a time to speak
Ecclesiastes 3:7

First-year student Bernard de Bhailís and transition-year student Enda Ó Donabháin demonstrate 'the hook up position', one of the brain gym exercises used by the Multiple Intelligence Programme. It is used to focus and magnetise the brain's thoughts in a very gentle and spiritual way, often equated with the joining of the hands for prayer.

and I made it myself

I sent you to reap ...and you have come into the rewards of their trouble.
John 4:38

With the guidance of the transition-year class at Críost Rí, the first-year student explains his project. The focus here is naturalist intelligence, a sensitivity to nature, texture, patterns, observation, and the abilty to group items. All the multiple intelligences are explored in this project. Antóin Ó Muirí explains the makings of his volcano to transition-year students Edbhard Crockett, Tomás de Buitléir and Daithí Breathnach.

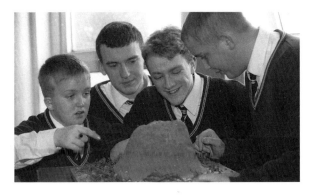

Multiple Intelligence involves complete partnership between school and home life, so parents get a chance to express their feelings and reactions to the project. Here with Anne Fleischmann they discuss their reaction to the music idea and a Multiple Intelligence focusing approach for their children.

'In my job I work with children, and sometimes I look at them and say, there must be good in them somewhere. By looking at the Multiple Intelligence theory, a glimmer of hope appears; you can smile and understand them and somehow among the thistles is a beautiful flower.'

Pat Walsh, Parent

ENCORE!

I have something to say to you. 'Speak' she replied.
 1 Kings 2:14

At the Presentation Secondary School in Crosshaven, the first-year French class comes alive, with students using a number of the multiple intelligences to master the subject. Erika Kind and Marian Jagoe illustrate French reading comprehension in the form of a play. Erika explains: 'If I look at my book all the time, I tend to get bogged down in the pronunciation. This way makes it is easier and more fun to learn.'

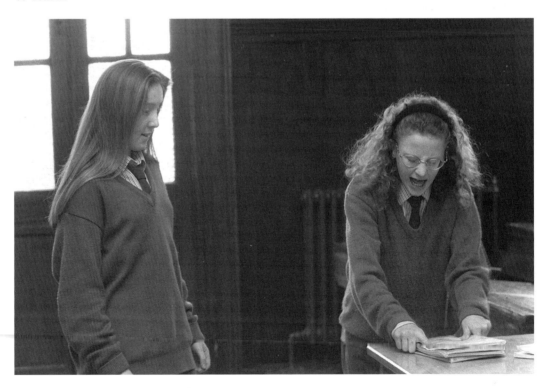

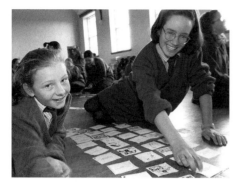
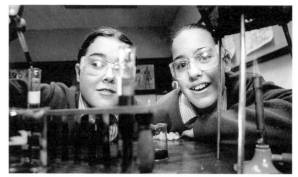

a voyage of discovery

Ask, and it will be given to you; search, and you will find; knock, and the door will be opened to you.
 Matthew 7:7

The students enjoy the hands-on involvement. On this voyage of discovery Rachael Murtagh and Debbie Sisk explore the whole human rights issue using a series of Amnesty games.

Science is also made fun. Second-year students Kate Murphy and Hayley Morrissey test the substances of red cabbage using an indicator.

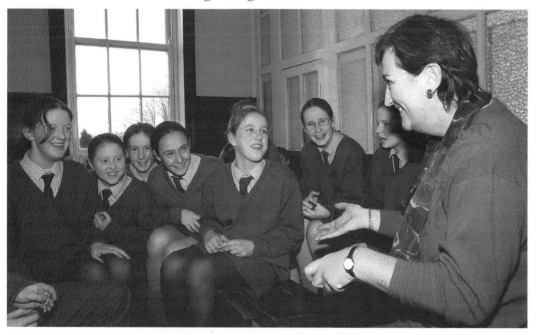

Norma Sugrue, Co-ordinator of Multiple Intelligence, with pupils in Crosshaven

long long ago

I will open my mouth in a parable and reveal hidden lessons of the past.
 Psalm 77:2

By using the visual-spatial and bodily-kinesthetic intelligences together, first-year students at Crosshaven script and act out their own stories. Here Marian Jagoe and Brian O'Mahony perform their own sketch for the class.

it's a rap

There are shouts of joy and victory in the tents of the just. The Lord's right hand has triumphed.
 Psalm 117:15

The focus for the first-year maths class in Crosshaven is logical-mathematical intelligence. This centres on people whose intelligence is geared at solving problems, experimenting with figures and thinking analytically. In the students' quest to find a way to make a maths rule easier, they devised a rap, which uses a number of the multiple intelligences. Tim Dempsey, Mairéad Green, Ciara Lewis and Gary Kelleher take on the task of using musical-rhythmic intelligence to uplift their performance:

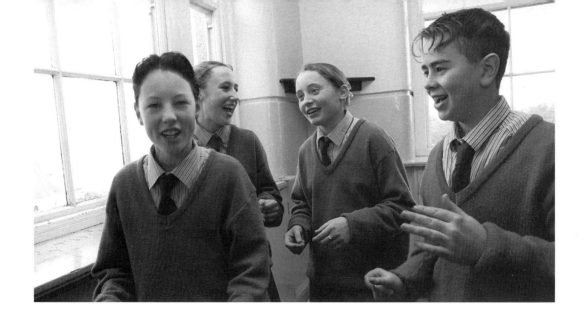

Adding and subtracting, teacher goes insane,
Now we've cured her, here's our game.
When signs are the same here's our rule,
Keep and add, now that's cool.
Different signs, here's our touch,
Which sign wins and by how much?

To multiply and divide,
Here's how we decide,
Two pluses or two minuses make a plus.
This is the rule as said to us,
A plus and a minus or a minus and a plus
Worked together minus all the fuss.

This is our rap, isn't it cool.
Now we know it rule by rule.

'As Professor Brendan Kennelly said: "Though we live in a world that always seems about to give in, something that will not acknowledge conclusion insists that we forever begin…". I suspect that Edmund Rice and Nano Nagle would be nodding in agreement.'

Anne Fleischmann 1998

Chapter Seven: **Compline - Parish Life**

The fishing town of Castletownbere and Bere Island, Co. Cork (a parish in the diocese of Kerry)

The curfew tolls the knell of parting day,
The lowing herds wind slowly oe'er the lea,
The ploughman homeward plods his weary way,
And leaves the world to darkness and to me.

Now fades the glimmering landscape on the sight,
And all the air a solemn stillness holds,
Save where the beetle wheels his droning flight,
And drowsy tinkling lulls the distant folds....

From 'Elegy in a Country Churchyard' by Thomas Gray

On a cold December day in 1997 we interrupted the people of Bere Island and the rural fishing town of Castletownbere, to document their lives. The Beara Peninsula is on the edge of the Atlantic ocean, virtually hidden from the rest of Ireland. We acknowledge the people whose lives are marked by sea, we admire their community spirit and uphold their strong commitment to survive in their parish.

I am the good shepherd

He is like a shepherd feeding his flock, gathering lambs in his arms, holding them against his breast and leading to their rest the mother ewes.
Isaiah 40:11

On this particular day, the Bishop of Kerry, Bill Murphy, visited the people on Bere Island. This, he believes, 'is important to the parishioners, especially the young and housebound, who are an important and valued part of the Church in this diocese'.

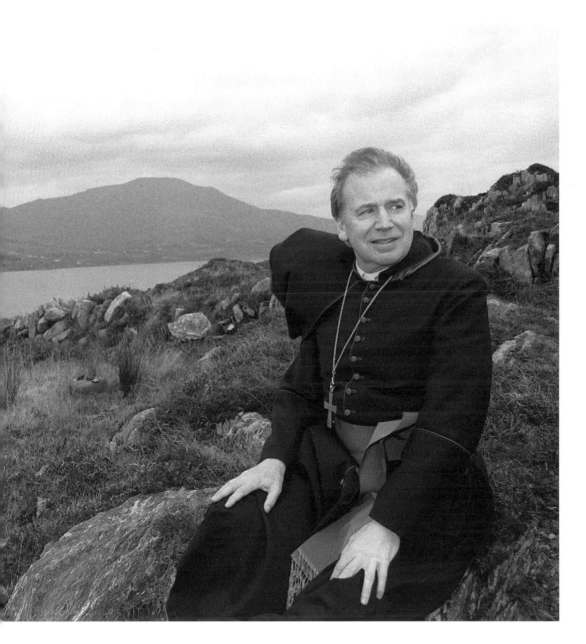

There was undoubted excitement about his visit that day. The bishop's commitment to meeting the people of the Kerry Diocese is greatly appreciated. These parish visitations have taken him to Oileán Bhéil Inse, north to Caisleán Ghriaire and west to Corca Dhuibhne. It clearly defines his own role as bishop, which is 'to proclaim and encourage others to proclaim the message of Christ in a language that is intelligible to people living on the threshold of the third millennium; to help people to pray and to worship God in accordance with our rich Catholic tradition; to develop a collaborative approach to ministry at diocesan and parish level that would mobilise all resources, lay, religious and clerical'.

The pupils of Scoil Naofa Mhicil, Bere Island, with their teacher, Kathleen Twomey

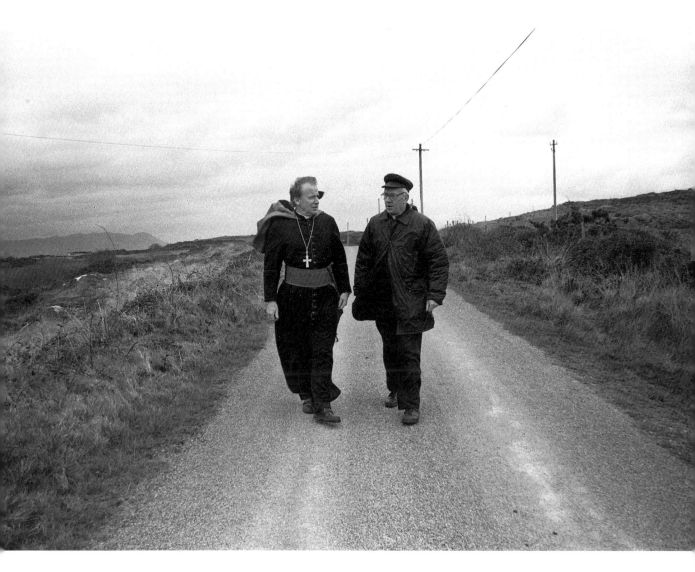

GO TO THE OPEN ROAD AND HEDGEROWS

Then the master said to his servant, Go to the open road and hedgerows, and force people to come in, to make sure my house is full.
 Luke 14:23

Bere Island lies close to the town of Castletownbere, accessible only by boat and a local ferry company. There is still an important military presence on the island. Though the island has a life of its own, with a church, a school, two grocery shops and two pubs, support from the neighbouring town is vital for its mainstays of fishing and farming. Fr Tim Vaughan has been priest on the island for the past eight years.

fishers of men

As Jesus was walking by the sea of Galilee he saw two brothers, Simon who was called Peter, and his brother Andrew; they were making a cast catching fish in the lake with a net for they were fishermen. And he said to them: 'Follow me and I will make you fishers of men'. And they left their nets at once and followed him.
 Matthew 4:18-20

The sea symbolises our faith in God. The water signifies a divine gift of grace from which we emerge and are baptised in life. Water is a gift of nature that gives life and sustenance to the soul, and then so unceremoniously takes it away. This powerful element of nature is a paradox, an immortal substance that is always surprising,

Finbarr Harrington, Brian Kane and Vincent Murphy waiting on the pier for the latest weather report

sometimes still yet never silent. Jesus called his disciples from the waters of Galilee to follow him and gather fishers of men to spread the good news about Christ. The lives of the fishermen are no different today. They are harvesters of the sea, bracing the elements at all times, hoping for a catch that will sustain their families, from whom they are separated in their work. In Castletownbere, fishing is at the heart of the people. As a parish they have witnessed the joys and the tragedies of fishing, which has woven the community together.

Mike Murphy was 'born, bred and reared in Castletown. I'm a fisherman for forty years, fishing the seas from Dursey Island to Mizen Head. I suppose we shouldn't be always worried about the elements; the worrying is whether you're going to make a catch or not. I love fishing, a free and healthy life, always fighting with the elements.'

Cast your bread upon the waters...

He went a little further and saw two other brothers, James and John, the sons of Zebedee. They were in their boat getting their nets ready. As soon as Jesus saw them, he called them; they left their father Zebedee in the boat with the hired men and went with Jesus.
 Mark 1:19-20

Fish also symbolise the Eucharist. In the time of Jesus bread and fish were the staple diet of the people, and Jesus showed the importance of this to his disciples when he performed the miracle of the five loaves and two fishes for the multitude that had gathered to hear him.

Denis O'Regan, skipper of the Spailpín Fánach, *putting in new meshes*

bless this boat

And his disciples came to him, and woke him saying, 'Save us, Lord, we are going down.'
And he said to them, 'Why are you so frightened, you men of little faith?' He stood up
and rebuked the winds and the sea; and all was calm again. The men were astounded
and said, 'Whatever kind of man is this? Even the winds and the sea obey him!'
 Matthew 8:25-27

Denis O'Connor is a full-time fisherman, fishing the seas from Mizen Head to the
Blasket Islands. 'A successful fisherman will always watch the forecast. I very seldom
get caught in stormy seas. Sometimes I find myself alone with God out there, and I
pray that everything will go all right.' Denis is ready to leave the harbour; he says
goodbye to his wife, Mary, who is the choirmistress in the church. There is an
uncanny silence to their goodbye, there is no rush to his departure.

The blessing of the boats is a very strong tradition in fishing towns, and
Castletownbere is no exception. The annual Mass takes place in the harbour's
auction room instead of the church.

Bless this boat
And all who sail in it.
Reward those who have laboured in its building.
Protect it in fair weather and foul,
And bring it to peaceful harbours
When the voyage is done.

Protect all seafarers in the duties and
Dangers of their calling.
Bless all who work to make safe the seaways
And all who work in the rescue services
Amen.

the unsung heroes

Greater than the roar of mighty waters, more glorious than the surgings of the sea, the Lord is glorious on high.
 Psalm 92:4

The RNLI rescue service offers a real sense of security for all who work at sea. The service in Castletownbere was set up by the local people in October 1997. It has a voluntary crew of twenty at any given time, drawn from all corners of the community – a teacher, nurse, garda, mechanic – the groundswell of support is enormous. As the RNLI relies on local fundraising, it needs all the resources available to it. It is this spirit that forms the very core of Castletownbere and its people.

O salty sea
How much of your salt
comes from the tears
of my people

An inscription at the
entrance to many
of the world's harbours

Fuchtnu O'Donoghue, John Edward Harrington, Maurice O'Donoghue, Paul Stevens, Laurie Griffin, Tony O'Sullivan, coxswain, and Paddy O'Connor

to serve god

Happy the merciful: they shall have mercy shown them. Happy the pure in heart: they shall see God.

Matthew 5:7-8

Sr Baptist Kirby is matron at Castletownbere County Hospital, which serves Dursey Island, Bere Island and all the Beara Penninsula. She has a staff of fifteen who care for thirty-three patients at the hospital. They also run a day-care centre and an ambulance service. As a Mercy Sister she has served in nursing for forty-four years. She says that she tries to display the love of God in her work with people, and tries to encourage young adults to visit the elderly in their homes or at the hospital.

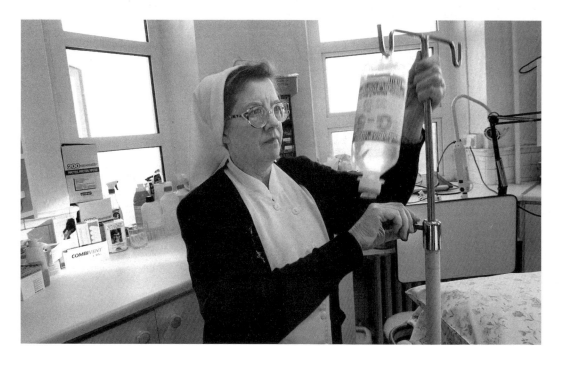

from the rafters

So now I say to you: You are Peter and on this rock I will build my Church: and the gates of the underworld can never hold out against it.
Matthew 16:18-19

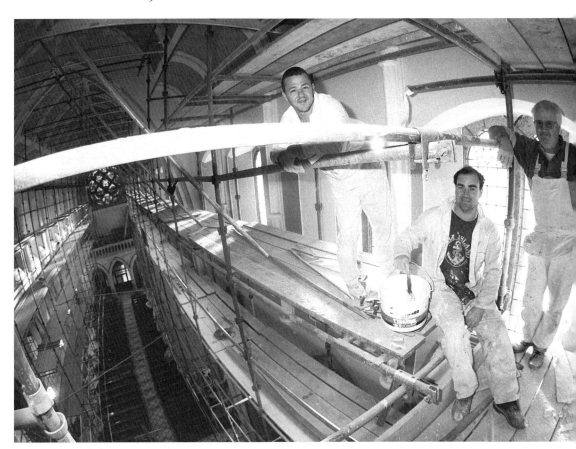

The church in Castletownbere undergoing renovation. Dedicated painters include Darren Murphy, Vincent Power and Michael Downey

STAR of the sea

For wisdom is quicker to move than any motion: she is so pure she pervades and permeates all things.
 Wisdom 7:24

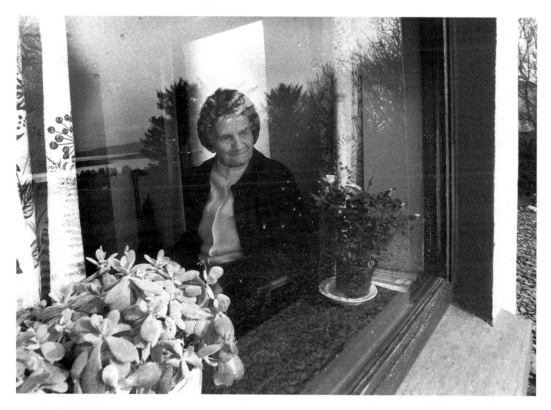

Maggie O'Sullivan, eighty-seven, lives in the townland of Filane about three miles from Castletownbere. She has lived all her life in Castletownbere. She never leaves the house now and clings to her rich faith. 'Where would we be without our faith? Sure we'd have nothin.'

teatime!

Beloved, let us love one another since love comes from God; and everyone who loves is begotten of God and knows God. Anyone who fails to love can never have known God, because God is love.
John 4:7-8

Fr Donal O'Connor is a teacher and chaplain in Beara Community School. He also works as curate in Castletownbere parish. He talks about his own life and the lives of the people he serves:

'Being a priest in any place is unique yet has so much in common with what you might call the "universal" priesthood. Every particular place has its own mood, as it were – yet the aches and pains, the hopes and hungers of the human heart are the same everywhere. I believe we all crave for connection in some form or other. We need to belong to someone or something. It is something at the very core of our being. Ultimately, it is the realisation of belonging and being loved by God. The "job" of the priest is to facilitate this connection – to create possibilities where the sense of belonging and the reality of God's totally unconditional love, become something real, something experienced.

I see my role here as one of trying in some way to "refound" the Church. The experience of God is for both young and old. It is not, I feel, about the "renewal" of the Church – that is a mistake often made by many people. In many ways Christianity today is faced with the same problems that faced Paul and the Church Fathers at the first Council of Jerusalem – how do you bridge and connect the wonderful mystery of Christ's death and resurrection with the culture of the time? It is, I believe, by trying in some way to make the Christian message real for people,

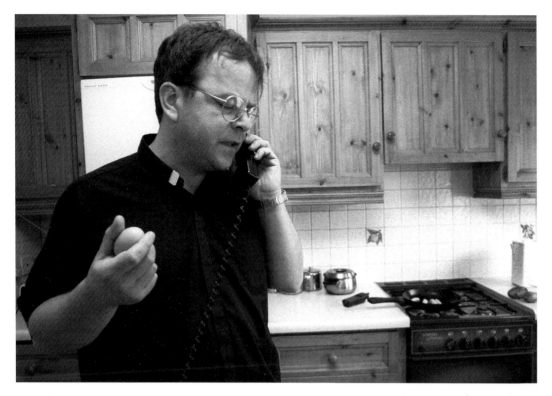

by adapting to every new generation. With young people in particular, who often have a complete sub-culture of their own, it involves walking to a place where possibly neither of you has been before. We have youth Masses, reconciliation services, speakers coming to the school. I am lucky in that there is a very good pastoral-care development team in the school. It is important to blend together the doctrinal, catechetical and experiential aspects of the faith. I suppose sometimes we put the cart before the horse, but I am thankful for all small mercies!

Underlying everything – the good, the bad and the ugly – I firmly believe the Christian message has something to say to the world, particularly to a country like Ireland, which like many others, has become so colonised by Hollywood and the all too frequently empty promises it makes. The Christian message is simple, yet profound. Whether we understand it or not, God is with us; he calls us, he saves us, he is on our side and offers an understanding, a hope and a meaning in life that we will not find anywhere else. That is what connection and belonging are all about – that is salvation. I love the Psalms – they have every heartbeat in their prayer. I find the morning the best (and often the quietest) time to pray. Prayer is the staple diet of any priest. Sometimes I do stray from that - sometimes it's easier to "talk" about prayer, but sometimes, too, thankfully, I talk a little less!'

the meeting place

Joy, then, is the object of my praise, since under the sun there is no happiness for man except in eating, drinking and pleasure. This is his standby in his toil through the days of life God has given him under the sun.

 Ecclesiastes 8:15

The local pubs in Castletownbere are an important part of the town's culture. Thirsty seafarers and fishermen make their way there after a time at sea to exchange stories. Like so many other towns in rural Ireland where sea, mountainside and cliffs are the physical environment, the local pub is at the very centre of their social life.

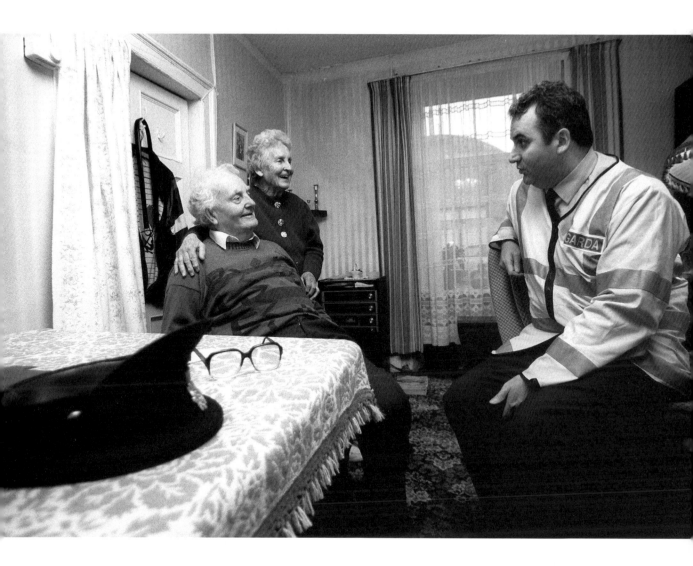

taking time

For he is our God, and we the people who belong to his pasture, the flock that is led by his hand.

 Psalm 94:7

Garda Martin Hegarty is stationed at Castletownbere. Along with his other duties, he is part of the local community alert and crime prevention committee. His role is to visit the elderly and retired citizens of the parish. Today he is visiting Patrick and Mary Crowley, retired local pharmacists. These important visits, like all pastoral-care and outreach programmes in parishes today, rely increasingly on the input of the laity for their survival.

Prayer of St Francis
Lord, make me an instrument of your peace:
where there is hatred, let me sow love;
where there is injury, pardon;
where there is doubt, faith;
where there is despair, hope;
where there is darkness, light;
and where there is sadness, joy;
O Divine Master, grant that I might not so much seek
to be consoled as to console,
to be understood as to understand,
to be loved as to love.
For it is in giving that we receive,
it is in pardoning that we are pardoned,
and it is in dying that we are born
to eternal life.

thank god it's friday!

You are God's chosen race, his saints; he loves you, and you should be clothed in sincere compassion, in kindness and humility, gentleness and patience. Bear with one another; forgive each other as soon as a quarrel begins. The Lord has forgiven you; now you must do the same. Over all these clothes, to keep them together and complete them, put on love.
Colossians 3:12-14

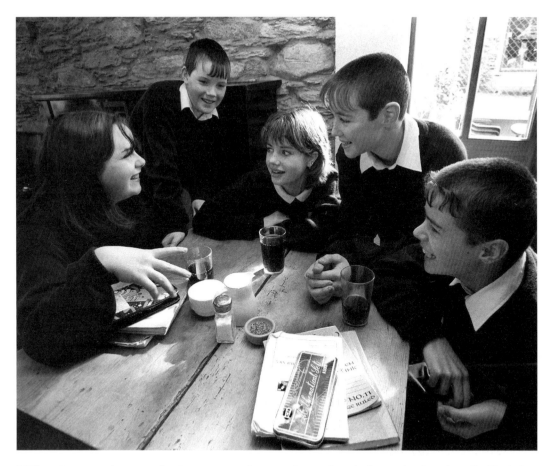

What better place to find some students after school than the local café. Deirdre O'Sullivan, Kieran Handley, Una O'Shea, Carl Cronin and Stephen Harrington are all first-year students at Scoil Pobail Bheara. Their needs are the same as those of students in any parish. Apart from school life, they are actively involved with a number of Kerry Diocesan Youth Service programmes, which is their only outlet both socially (discos, talent shows, sports days) and spiritually (GIFT programme). They have no difficulty expressing their own faith. Una O'Shea says that 'God has always been important in my life. I pray when I need something. Sometimes it's hard to pray when someone you love dies; then you ask why God didn't save him. That's hard…but you can't give up'.

'The most significant sign of life in the Church in Ireland as we near the third millennium is undoubtedly the ever-increasing involvement of the laity in the life and mission of the Church, especially at parish level.'

Bill Murphy, Bishop of Kerry